MARCH OF THE TEDDY BEARS

MARCH OF THE TEDDY BEARS

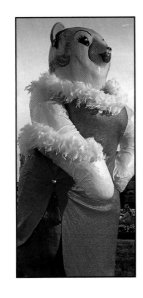

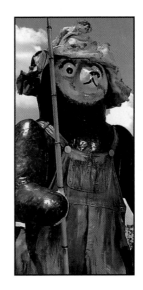

PHOTOGRAPHS
BY TIM JANICKE

KANSAS CITY STAR BOOKS

March Of The Teddy Bears
Kansas City 2002

Editor: Doug Weaver
Photography: Tim Janicke
Design: Vicky Frenkel

All rights reserved.

Published by Kansas City Star Books.

First edition.

ISBN: 0-9722739-0-5

Printed in the United States of America by Walsworth Publishing Co., Marceline, Mo.

To order additional copies, call StarInfo at (816) 234-4636 and say "BOOKS."

Or order on-line at www.TheKansasCityStore.com

Portions of the proceeds of this book benefit Children's Mercy Hospitals & Clinics and the Toy & Miniature Museum of Kansas City.

TABLE OF CONTENTS

MARCH OF THE TEDDY BEARS

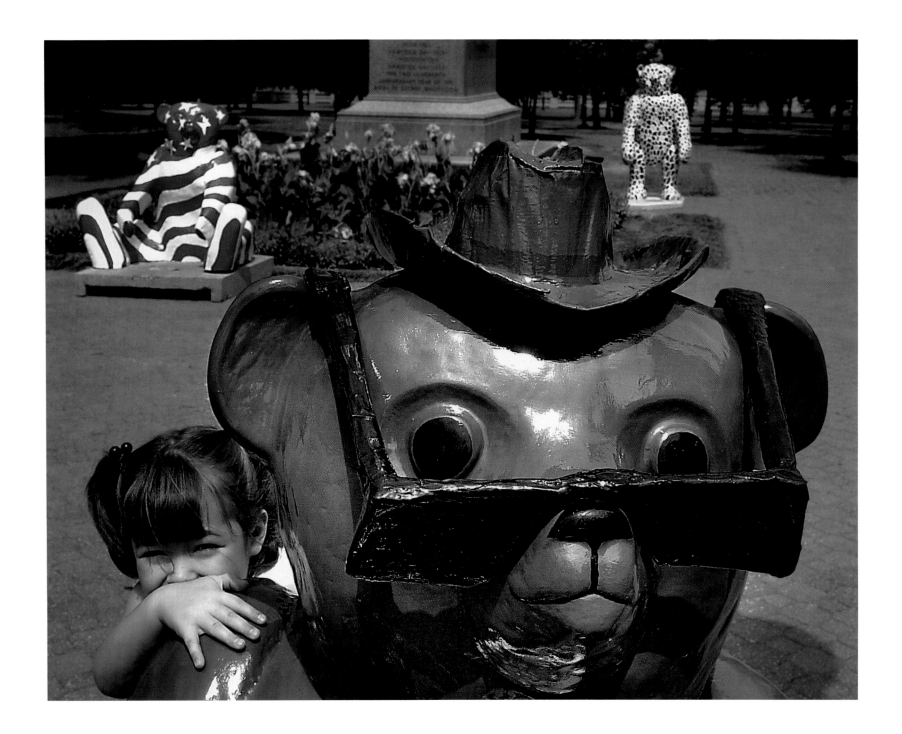

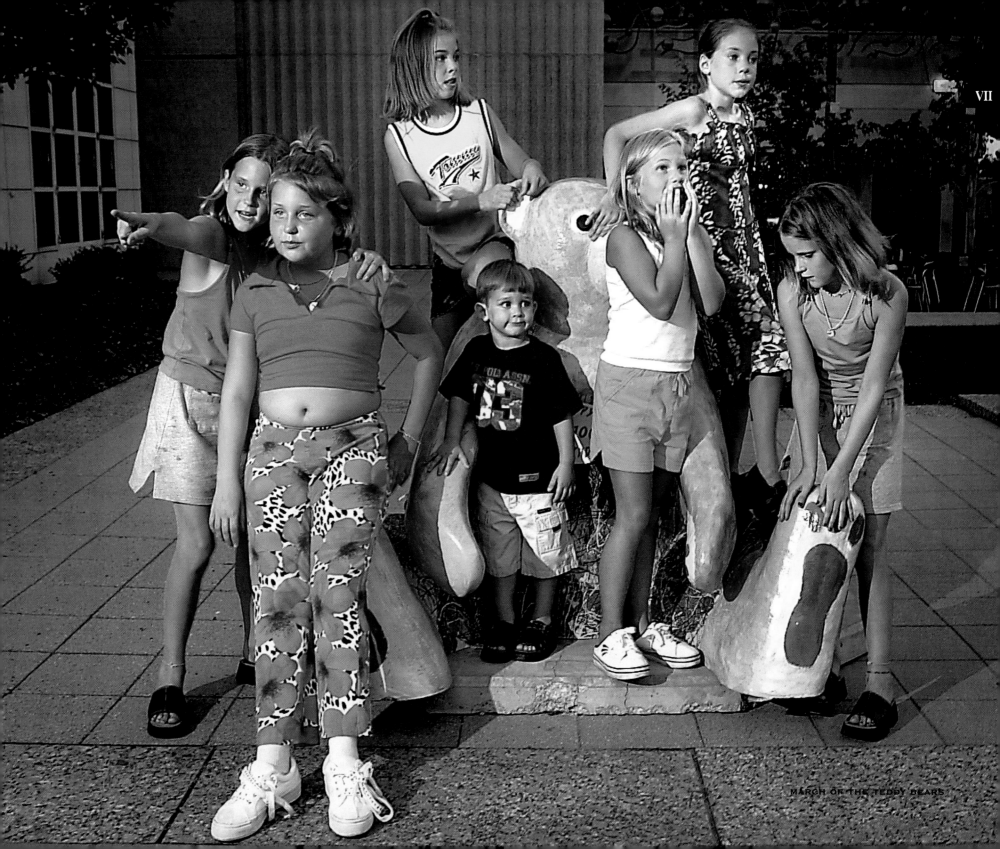

MARCH OF THE TEDDY BEARS

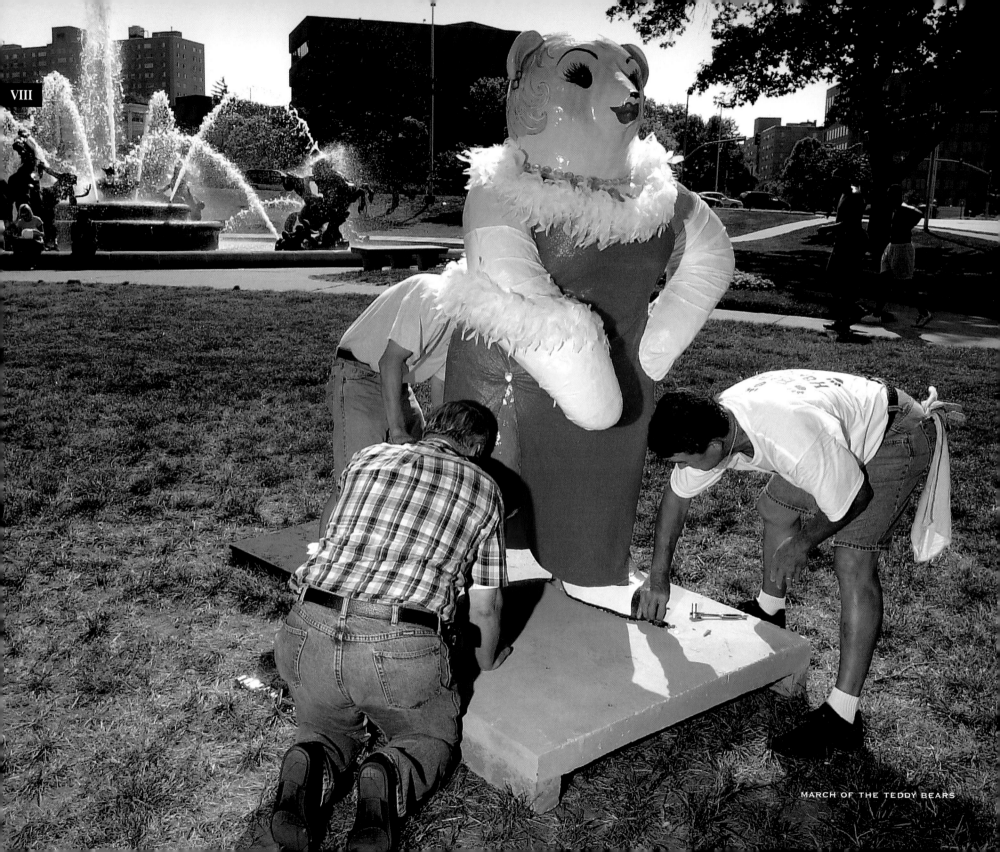

MARCH OF THE TEDDY BEARS

INTRODUCTION

With the cows turned out to pasture from the 2001 CowParade, there certainly was space for something new in Kansas City's fiberglass menagerie.

Teddy Bears, let's march!

And what a march it has been. With more than 150 bears situated in and around Kansas City through the summer and winter of 2002, the March of the Teddy

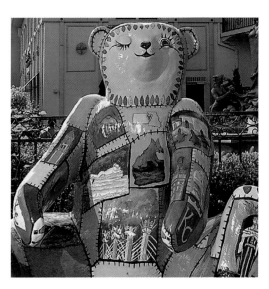

Bears has turned the town into a festival of color, bear hugs and cuddly-bear names, like "Huggable," "Bubblegum" and "Huckle Bear."

"I think they're a splendid idea," remarked Peter Russell, who was among the 200 people attending the official kickoff of the March in June.

He and Lesley Kennedy diverted their vacation by thousands of miles to see the March. The two London residents, who had been touring Canada and New England on a motorcycle hauling a trailer, arrived in town a few

days prior and had been bear-hunting since.

"We like the whole idea of the bears, and so we are launching ourselves out this evening, when it's a bit cooler, to see if we can find a few more," Russell said.

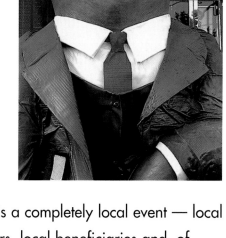

Unlike parts of the CowParade, the March is a completely local event — local organizers, local sponsors, local beneficiaries and, of course, local artists who worked countless hours to bring their imaginative designs to life.

Olathean Marilyn York created "Bears Repeating" in about a week and a half, spending more than $200. York also made two cows in the CowParade last summer, but she said the teddy bear was harder.

"I feel like I can't do gags as freely with a teddy bear as I could with a cow," York said. "They're childhood toys. They're almost sacred."

But there are teddy bear puns a'plenty among the bears and bear fans, starting with the critter names: "Su Bear Man," "Tabearsco," "Bearister" and "Bearying Your Head In The Sand," to mention just a few.

Also unlike the CowParade, there's a splendid moment in history being celebrated as part of the March: Teddy Bear's 100th anniversary.

It was in 1902 when President Theodore Roosevelt happened to be on a hunting trip. But the only bear the president found that day was a smallish bear that Roosevelt didn't have the heart to shoot. It would not be sporting, he said.

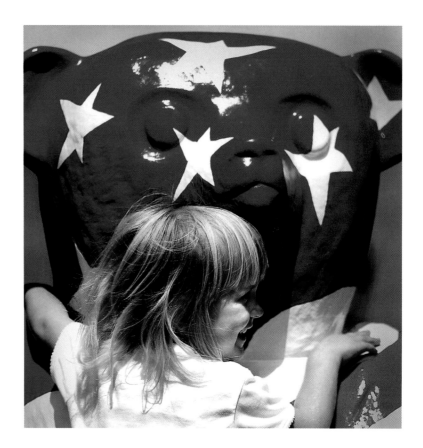

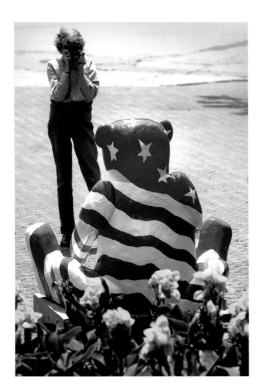

That next day, a cartoon of the incident appeared in the *Washington Post* newspaper, and a New York shopkeeper began displaying a stuffed bear in the window of his store made by his wife. The couple's bear was so popular, they sought the president's permission to call it a "Teddy Bear." Roosevelt said yes, and the rest is history.

The toy's popularity received a further boost in Germany when Margaret Steiff of the Steiff Company produced stuffed bears about the same time. An American buyer purchased thousands for import to the United States to meet growing demand.

Whatever its roots, the teddy bear today is one of the world's most popular collectable items. It's not hard to

explain the excitement, then, when the tiny teddy shows up in six-foot fashion on the streets and parks of the Kansas City metro area.

CHARITY GOAL: $500,000

The March Of The Teddy Bears is ultimately a charity event for Children's Mercy Hospitals & Clinics and the Toy & Miniature Museum of Kansas City. In turn, Kansas City Mayor Kay Barnes has proclaimed 2002 as "The Year of the Teddy Bear" in Kansas City.

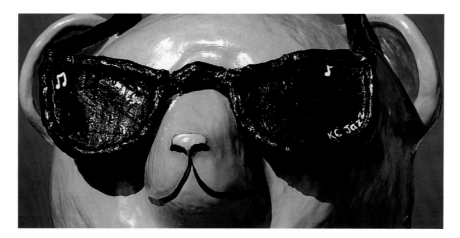

"As far as we know, Kansas City is the only major American city holding a celebration of the 100th anniversary of the teddy bear," says Joyce Morrison, a spokeswoman for MAI Sports, which is overseeing the event.

Selected bears will be sold at an auction in October. The remaining bears will be available for purchase in an Internet auction.

The goal: Raise $500,000 for the hospital and the museum. The museum, which came up with the idea for

the bears, plans to put its share of the proceeds toward more exhibit and office space, an auditorium and educational programming. Children's Mercy will use its proceeds to help pay for four new operating rooms for cardiovascular surgery.

There are dozens of businesses, organizations and individuals supporting the project. The lead sponsor is The Kansas City Star Co., whose book division is publishing this book and others about the March. (For a list of artists and sponsors, see the indexes at the back of this book.)

More than 120 fiberglass bears are being displayed between July 6 and Sept. 28 in dens throughout the metropolitan area. Then, in November, a second set of bears — dubbed "holiday bears" — will emerge from hibernation in time for the holiday shopping season.

Prime bear-watching areas include the Plaza, Union Station, Liberty Memorial, Crown Center, The Kansas City Star and Starlight Theatre, but the bears are scattered virtually everywhere — in Liberty, Mo., Lee's Summit, Mo., Leawood, Kan., and elsewhere.

A bear is born

COME ALONG AS WE FOLLOW THE MARCH FROM MOLD TO FINISH

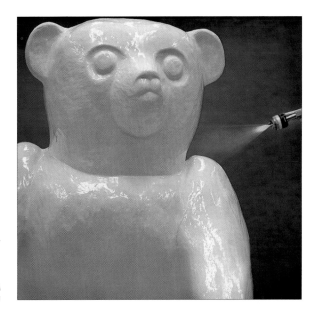

The BEAR necessities

WE TRACK A TEDDY FROM ITS DESIGN TO ITS DISPLAY

It was June 2002 that the bears began their march through Kansas City.

Months back, though, the bears were little more than a gleam in the eye of artist Judy Tuckness, who was charged with sculpting the forms that Kansas City artists would use to create the whimsical teddys.

Tuckness fashioned both a standing and a sitting bear from clay in the dining room of her Lenexa home. Her husband, Don, helped fabricate the underpinnings of the clay molds.

March of the Teddy Bears officials approached Tuckness to design the teddy-bear blanks because she had decorated CowParade cows and served as the cow doctor last summer, repairing injured bovines.

Tuckness sketched designs based on a stuffed bear at the Toy & Miniature Museum in Kansas City.

After Tuckness finished sculpting the bears, she trucked them to Hemco Corp., an Independence manufacturer. Workers at Hemco fashioned molds and sprayed them with fiberglass. Each bear design came out of the fiberglass mold in two pieces. Hemco workers riveted together the fronts and backs, sanded and filled the seams, and painted the finished products.

Beginning in March, Kansas City artists, including Tuckness, went to the Hemco loading dock to pick up their bear blanks. Tuckness took one of the first blanks and decorated Theo-Bear Roosevelt, which was unveiled at a press conference in April and has appeared at other March of the Teddy Bears promotions. She has since done five more bears.

The first of more than 100 finished bears hit the streets at a private preview at the Toy & Miniature Museum. Several Tuckness creations are on view there, including the Bearly Balanced Bearninis, one of which you see Tuckness finishing on these pages.

Tuckness began planning and designing in January, making models in February and decorating in March. This written account follows Tuckness as she molds a bear; as Hemco makes the fiberglass copies; and as Tuckness decorates a bear for the Bearly Balanced Berninis installation at the Toy & Miniature Museum.

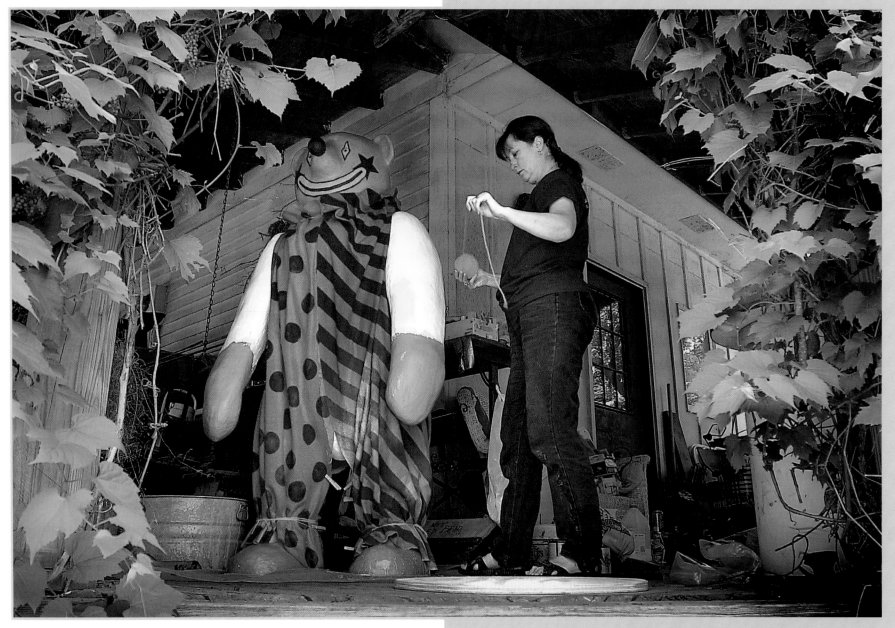

On her Lenexa porch, Judy Tuckness decorates a performer for the "Bearly Balanced Bearninis," a teddy bear circus unveiled at the Toy & Miniature Museum. Tuckness is the artist who created the mold from which all the bears were cast.

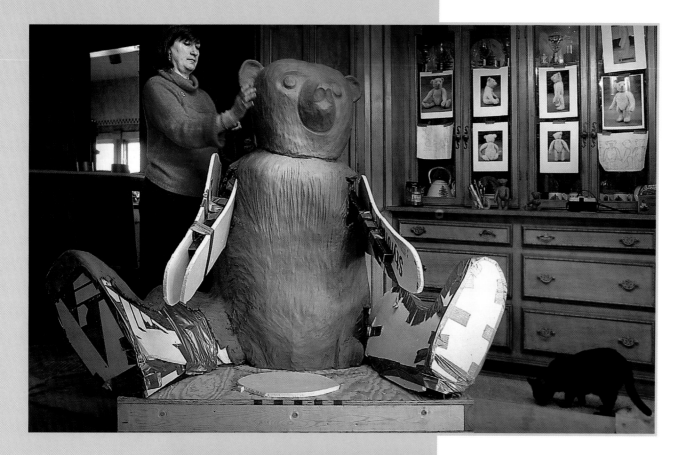

1

Top left: In February, Tuckness' dining room became the design studio for the original bears — one sitting, another standing. First, husband Don fashioned a framework from steel, Styrofoam and duct tape.

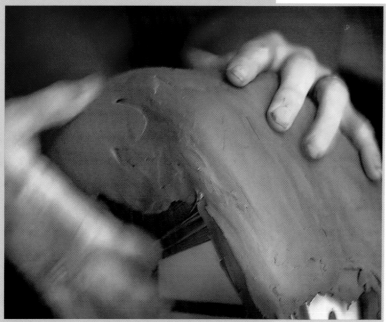

Bottom left: Here, Judy applies clay to transform the frameworks into bears. The couple trucked the clay models to Hemco Corp. in Independence to be cast and duplicated.

2

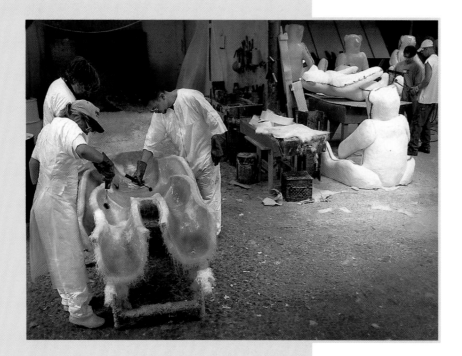

Left: Hemco workers made molds of the front and back of Tuckness' models. For each bear, they spray fiberglass into the molds.

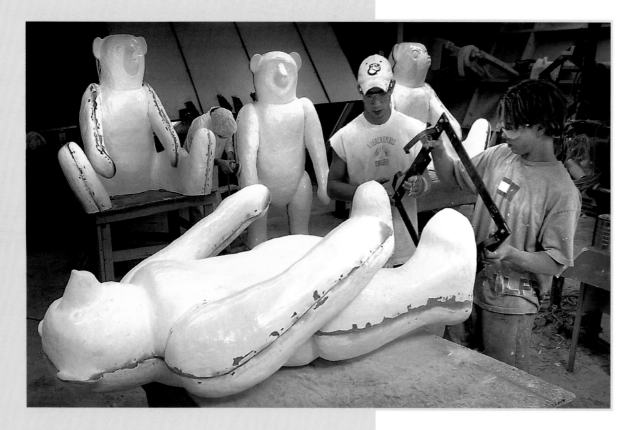

3

Left: When the fiberglass is dry, workers remove the pieces from the mold, rivet them and attach mounting brackets to the bottoms.

4

Right: The next stop is the Hemco paint booth, where bears get a final coat of white paint.

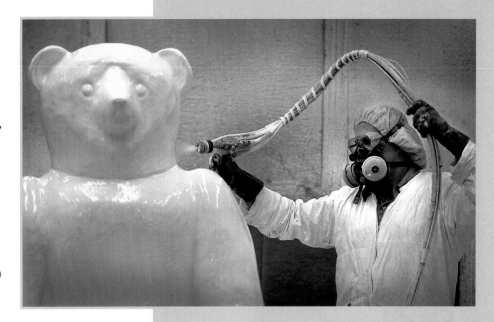

5

Below: These bear blanks are lined up on the Hemco loading dock, awaiting artists to pick them up. The 4-foot-tall sitting bear and 6-foot standing bear each weigh about 75 pounds — naked, that is.

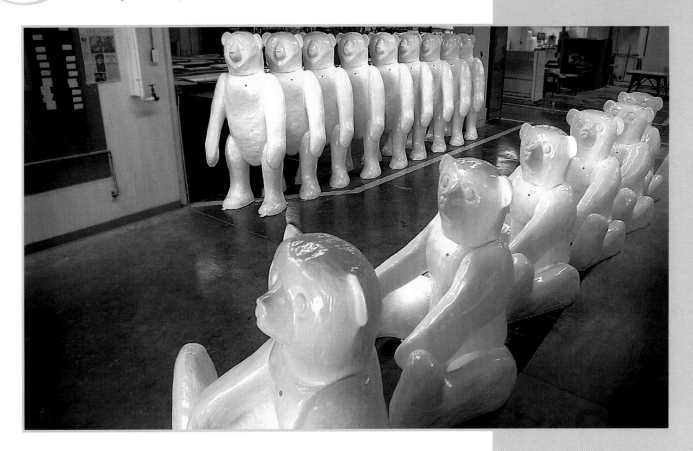

MARCH OF THE TEDDY BEARS

DEN 1

CHILDREN'S MERCY HOSPITAL

The Children's Mercy health-care system is one of the premiere children's care systems in the Midwest. It includes the main hospital at 2401 Gillham Road in Kansas City, plus clinics in Midtown, Johnson County, Kan., and outlying communities. Patients come from around the globe for treatment.

The hospital's history began in June 1897 when two sisters — Dr. Alice Berry Graham, a dentist, and Dr. Katharine Berry Richardson, a physician — earned a reputation for helping poor, sick children.

Part of the proceeds of the March of the Teddy Bears goes to the hospital system.

One bear in particular is modeled after the hospital's mascot, Mercy Bear (page 17).

MARCH OF THE TEDDY BEARS

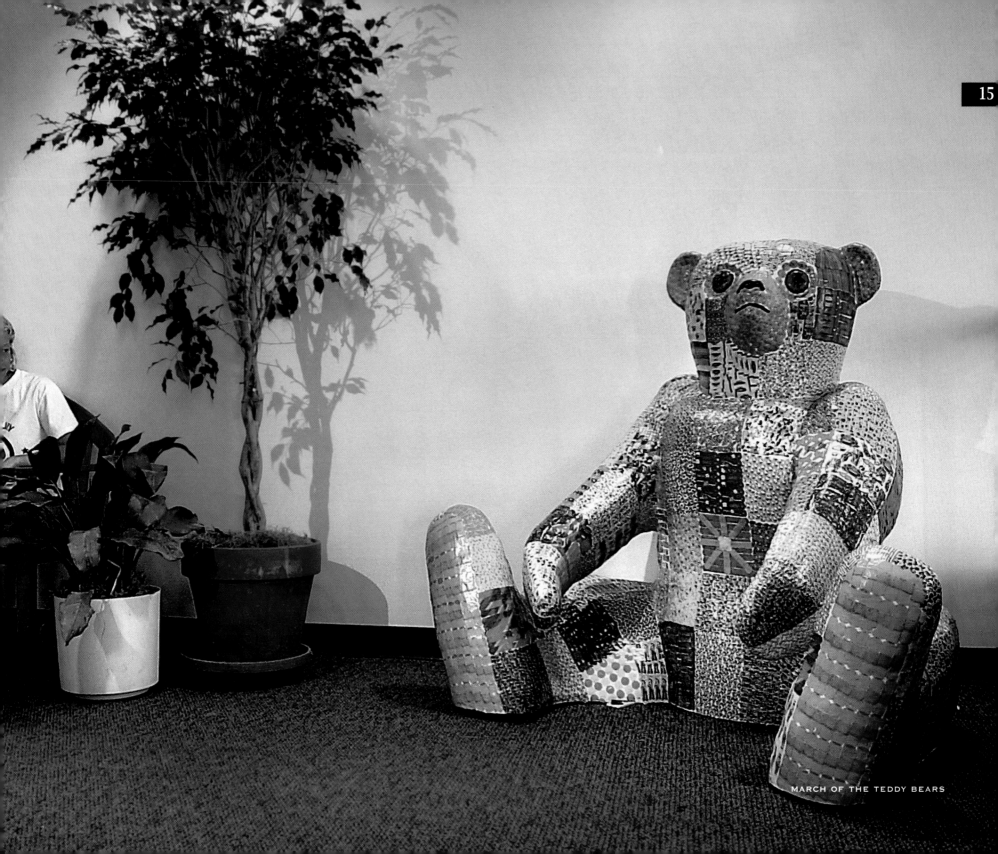

MARCH OF THE TEDDY BEARS

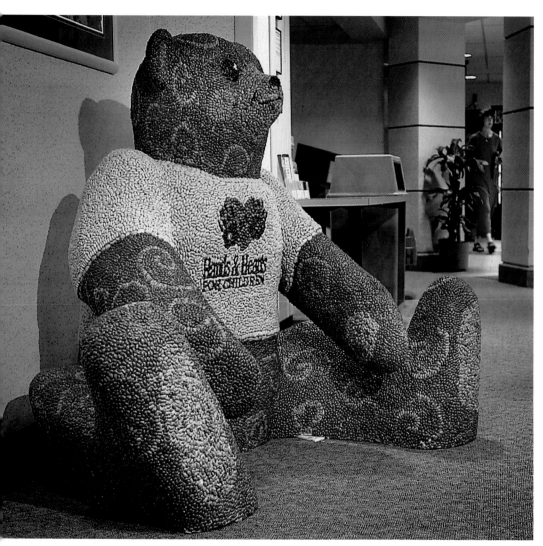

Huggable
Artist: Tammy Nigus
Patron: Friends of Children's Mercy Hospitals & Clinics

Jungle Bear
Artist: Dave Fisher
Patron: Friends of Children's Mercy Hospitals & Clinics

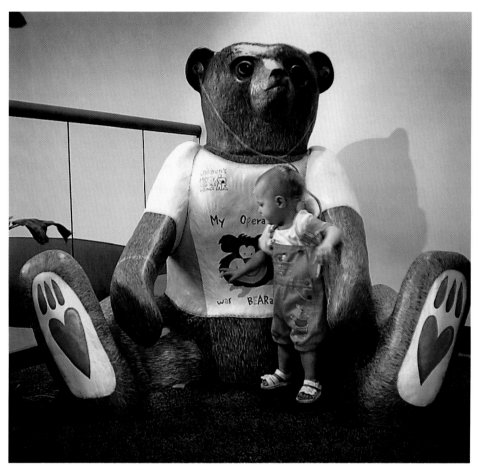

Mercy Bear
Artist: Karen North
Patron: Friends of Children's Mercy Hospitals & Clinics

Tabatha, the Boo-Boo Bear
Artist: Melissa Stover & Children's Mercy Teen Advisory Board
Patron: Friends of Children's Mercy Hospitals & Clinics

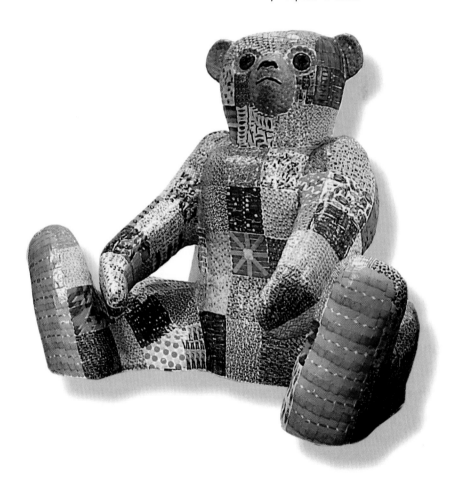

THE COUNTRY CLUB PLAZA

What better setting for one of the largest bear dens in Kansas City! The Plaza, founded by real estate developer J.C. Nichols early in the 20th Century, is considered one of the first shopping districts in the world designed to accommodate a buying public used to traveling by automobile.

The area has long been considered Kansas City's premiere shopping district because of the care Nichols took in introducing sparkling fountains, striking sculpture and a lavish architectural style to the retail surroundings. More recently, a number of large Kansas City employers have moved offices to the area.

Here you will find bears befitting this mix of shops and offices — from "Bearister" to "Beary Tourist" to "Bubblegum Bear."

MARCH OF THE TEDDY BEARS

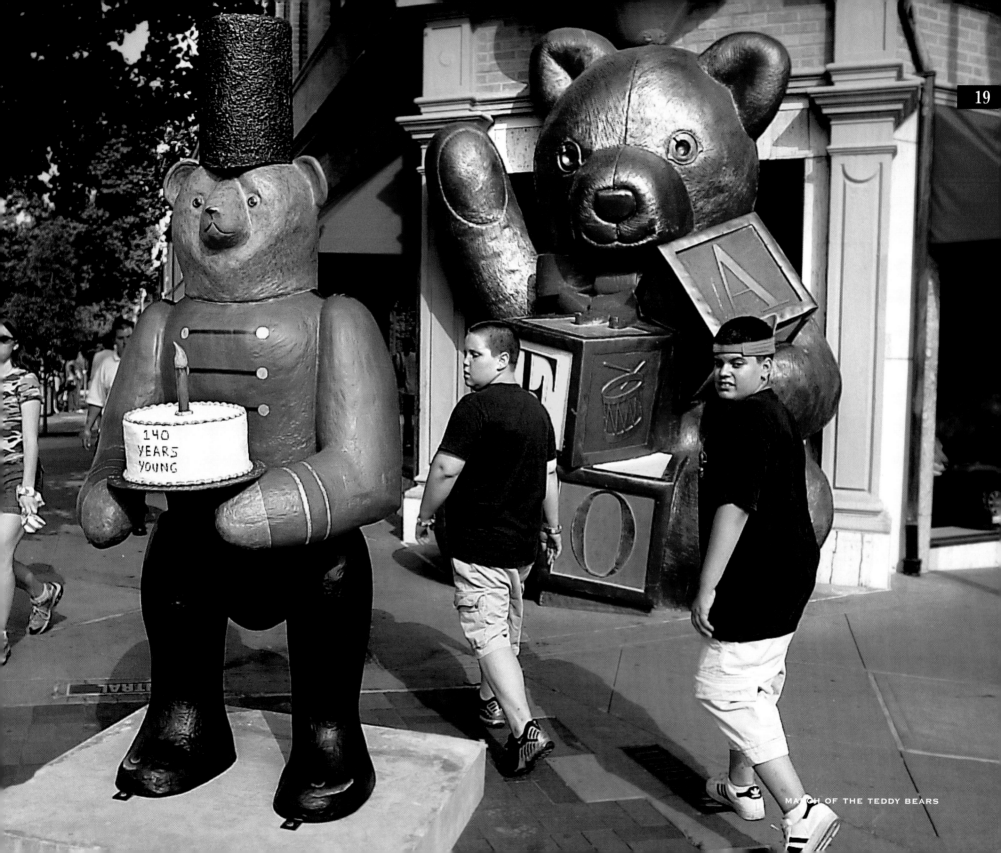

MARCH OF THE TEDDY BEARS

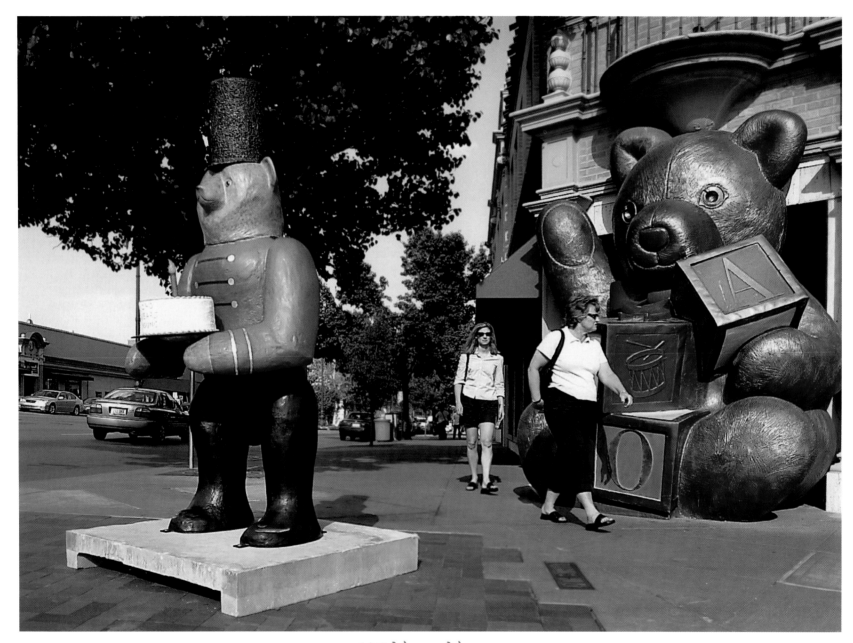

140 Years Young
Artist: Karen North
Patron: FAO Schwarz

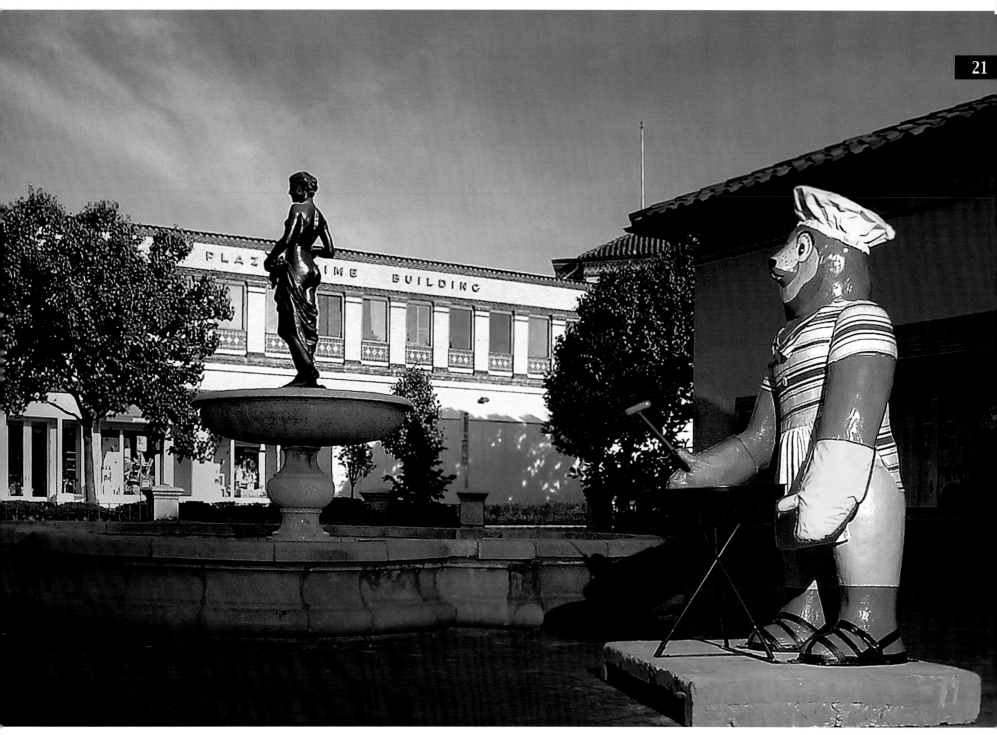

Bear B-Q
Artist: Herman A. Scharhag
Patron: Highwoods Properties

MARCH OF THE TEDDY BEARS

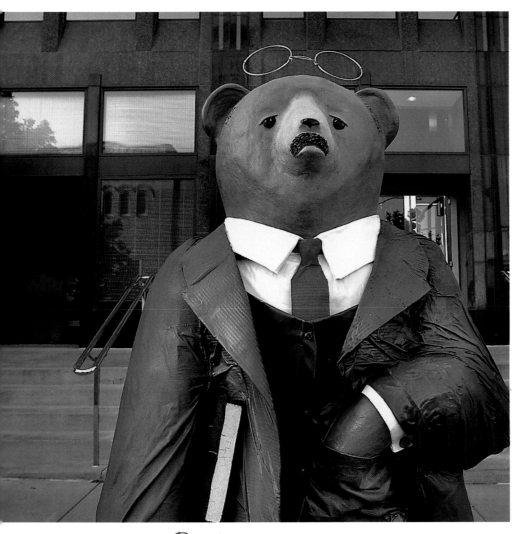

Bearister
Artist: Roger Garner
Patron: Polsinelli, Shalton & Welte, P.C.

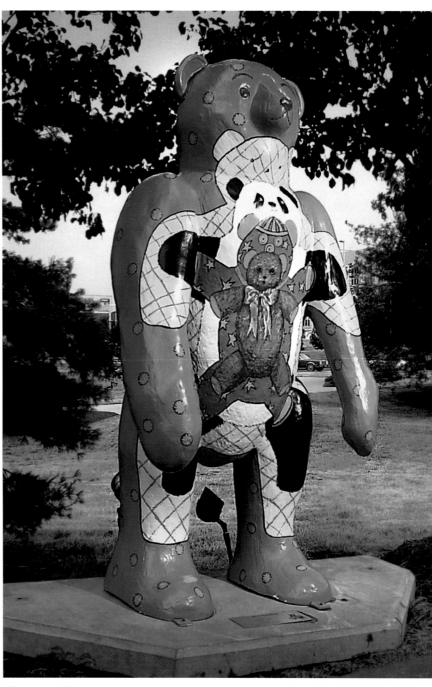

Bears Repeating
Artist: Marilyn York
Patron: Grand Street Cafe

MARCH OF THE TEDDY BEARS

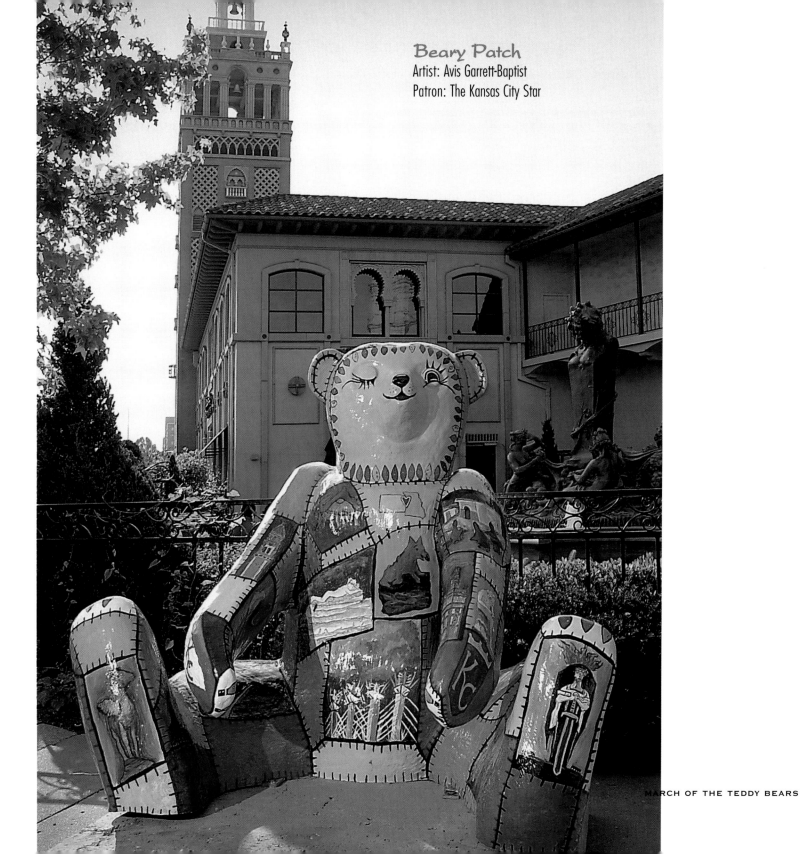

Beary Patch
Artist: Avis Garrett-Baptist
Patron: The Kansas City Star

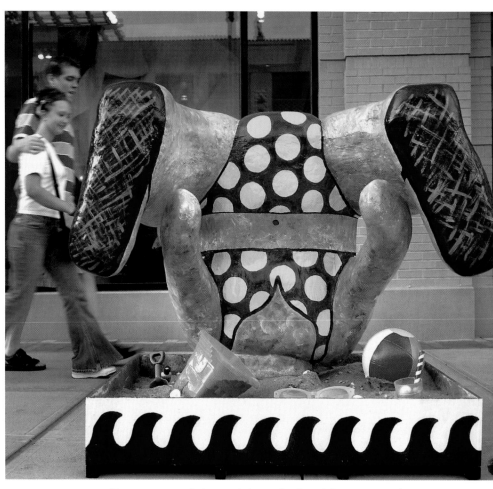

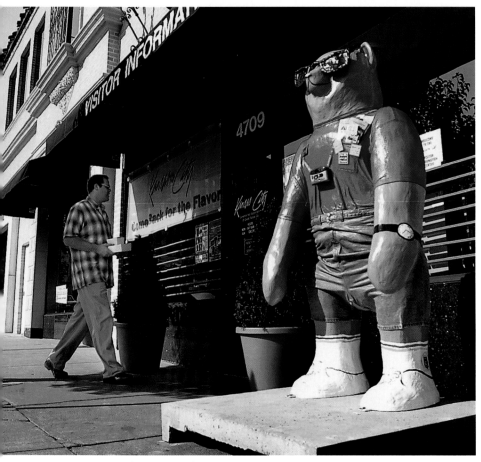

Beary Tourist
Artist: Carrie Cronan
Patron: Convention & Visitors Bureau of Greater Kansas City

Bearying Your Head In The Sand
Artist: Montica Alexander
Patron: Highwoods Properties

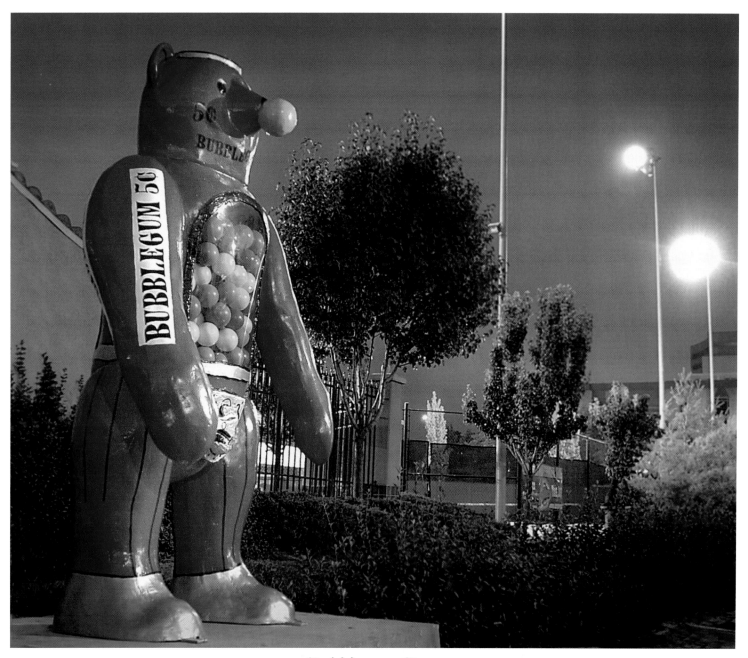

Bubblegum Bear
Artist: Donald Weeks, Sr.
Patron: Executive Marketing Promotions, Inc.

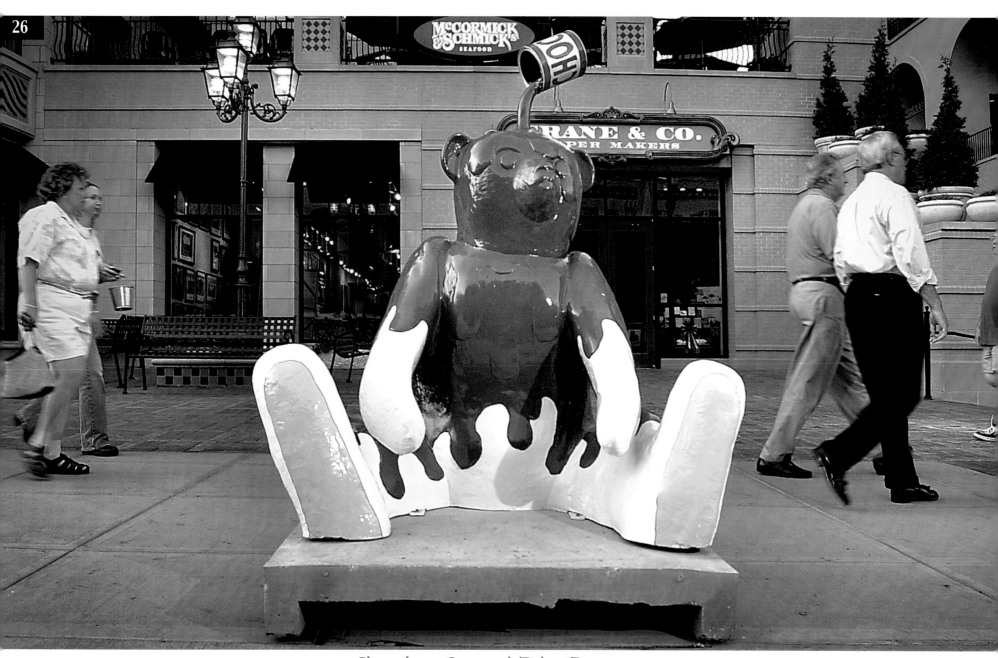

Chocolate Covered Polar Bear
Artist: Dave Fisher
Patron: Adelaide C. Ward

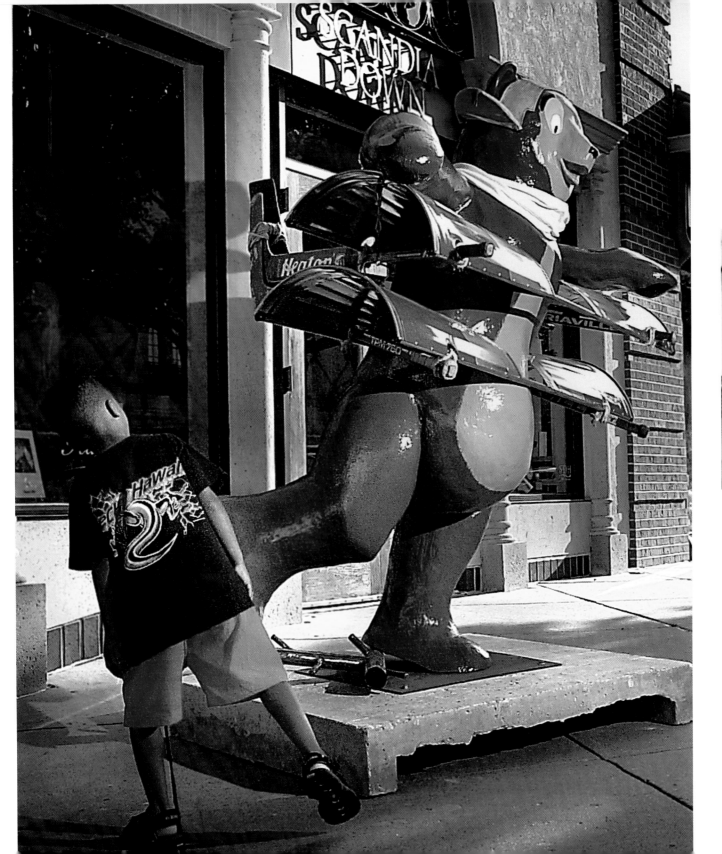

Flight of the Red Bear-on
Artist: Mike Jadud
Patron: Highwoods Properties

I Am Loved
Artist: Robert and Valerie Wolf
Patron: Helzberg Diamonds

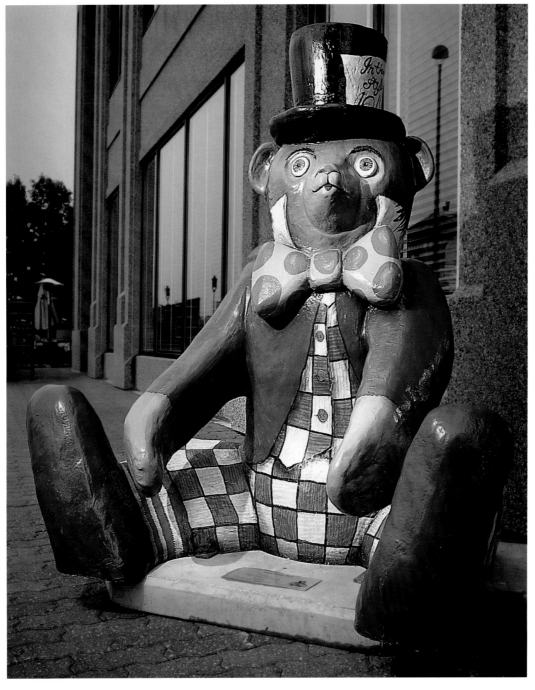

Mad Hatter Bear
Artist: Alice Bracken-Carroll
Patron: Grand Street Cafe

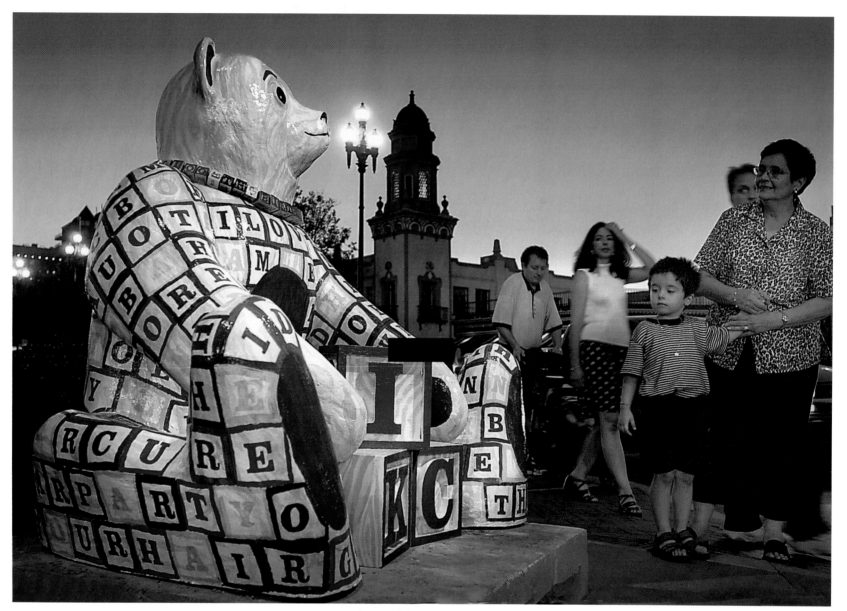

Grin and Build It
Artist: Julie Ann Strum, Kathy Wehmueller, Susan DeVoss & Betsy Ulvang
Patron: JE Dunn Construction

Willie Shakesbear
Artist: Alice Bracken-Carroll
Patron: American Century

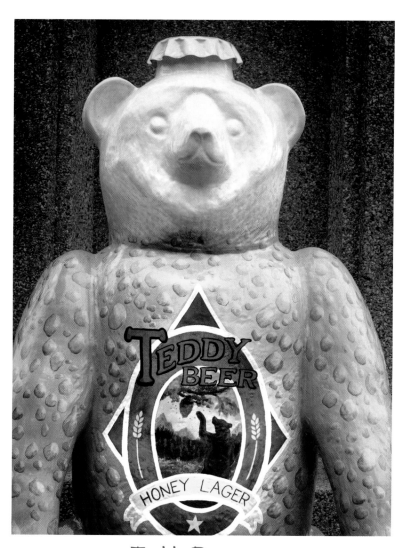

Teddy Beer
Artist: John Lewis
Patron: Grand Street Cafe

CROWN CENTER

There are said to be three "downtowns" in Kansas City, where people tend to gather to work and shop: The true and oldest Downtown hemmed in between interstate highways above the Missouri River; the Country Club Plaza near Brush Creek to the south; and in between — Crown Center Plaza.

The office and retail complex is owned by Hallmark Cards, the greeting card giant. Joyce C. Hall, the company's founder, started the company in Kansas City from very meager beginnings at the age of 18. Since, Hallmark has grown into one of the largest and most trusted corporate brands in the world.

Crown Center symbolizes not only Hallmark Cards' business strength but also its commitment to Kansas City. Here you'll find some of the most creative bears-very appropriate, given that Hallmark's offices nearby are packed with talented writers and artists.

MARCH OF THE TEDDY BEARS

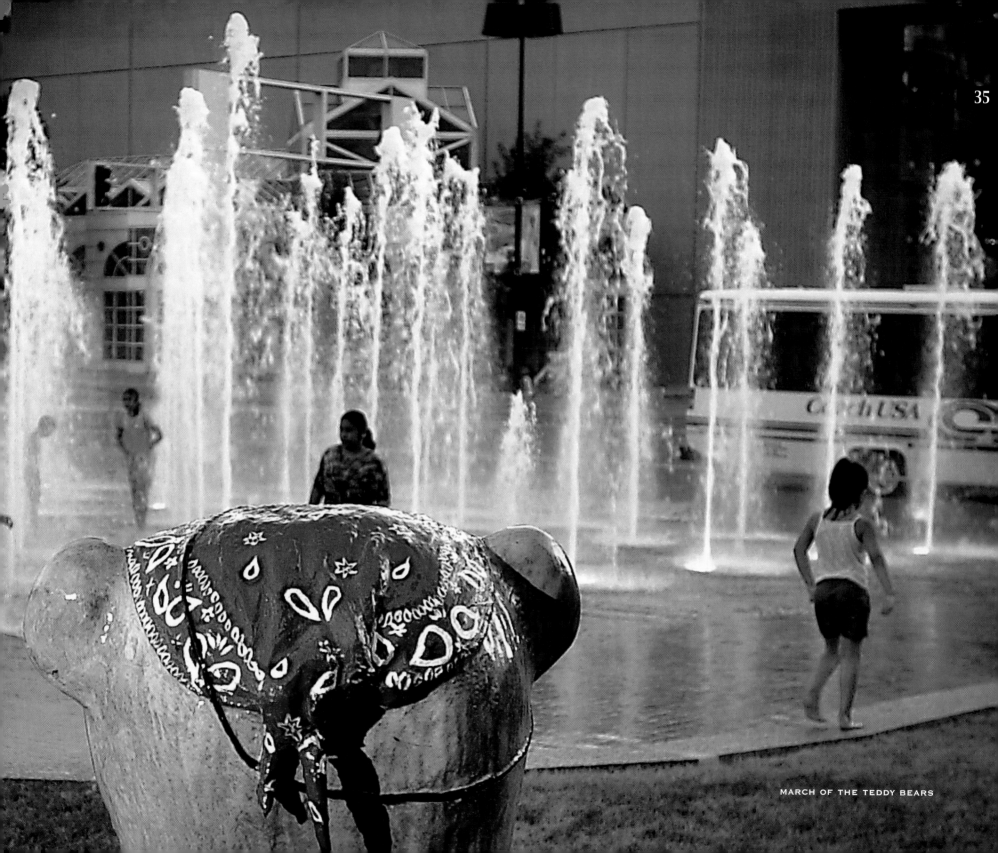

MARCH OF THE TEDDY BEARS

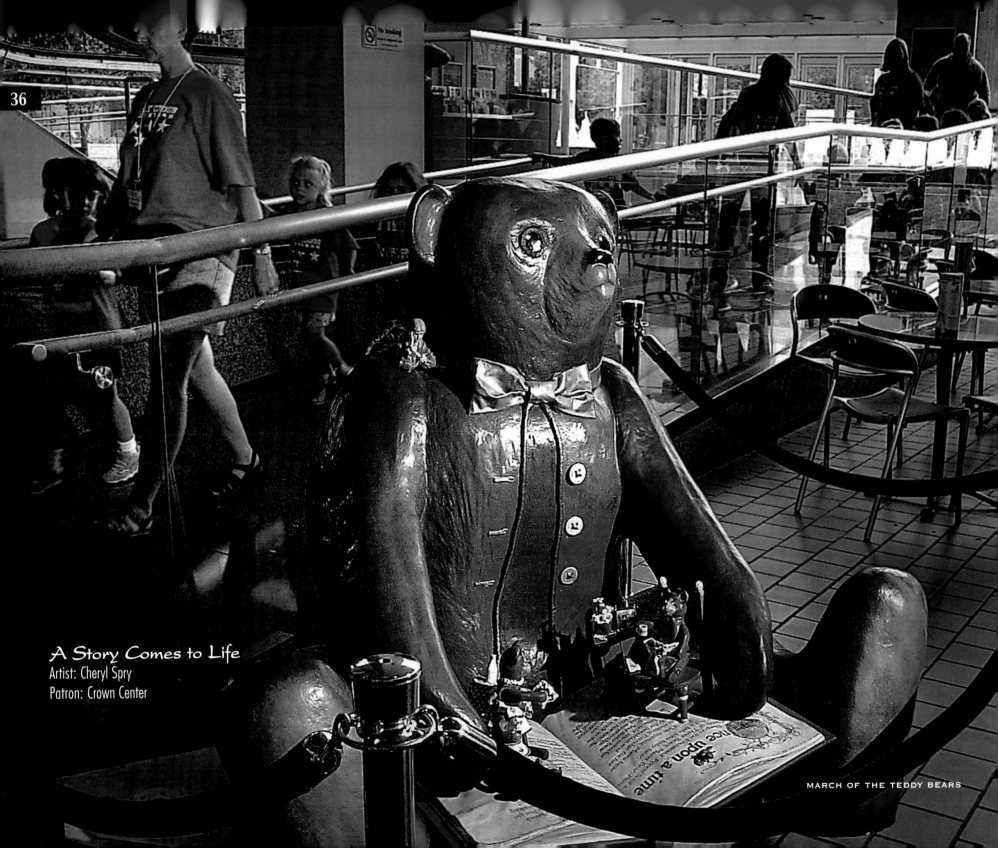

A Story Comes to Life
Artist: Cheryl Spry
Patron: Crown Center

MARCH OF THE TEDDY BEARS

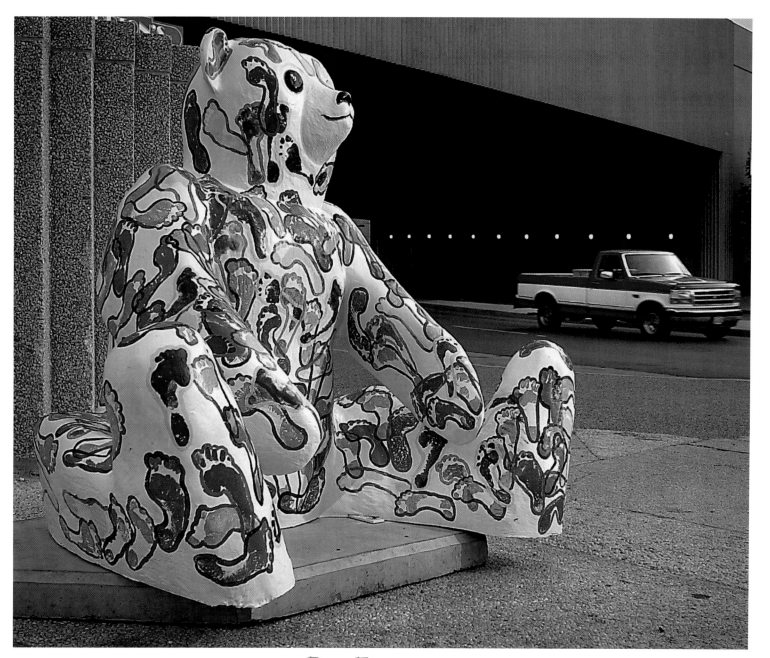

Bear Feet
Artist: Teri Siragusa Rattenne
Patron: Thomas M. Johnson, M.D. Charitable Fund

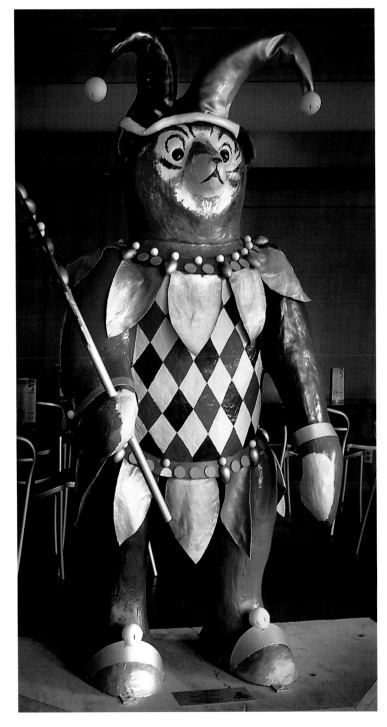

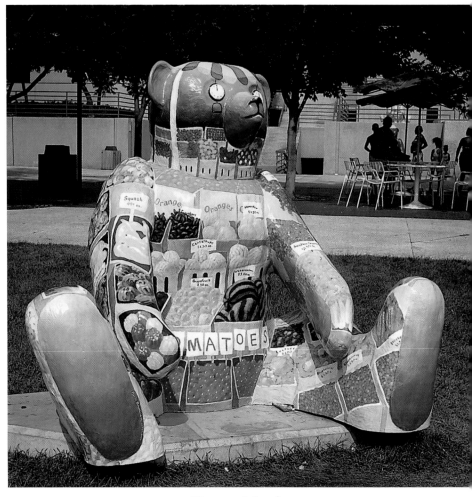

Bear Market
Artist: Kevin Brunner
Patron: Crown Center

Bear Foon
Artist: Herman A. Scharhag
Patron: Executive Marketing Promotions, Inc.

The Cabinet is Bear
Artist: Judy Tuckness
Patron: Executive Marketing Promotions, Inc.

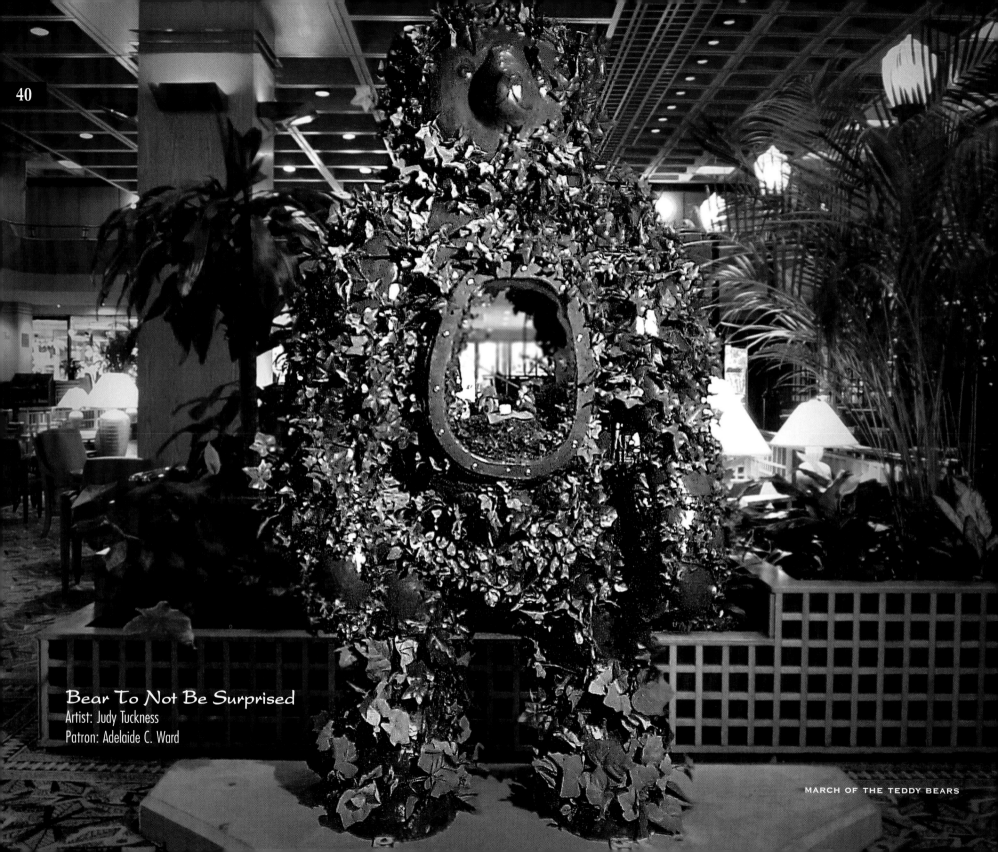

Bear To Not Be Surprised
Artist: Judy Tuckness
Patron: Adelaide C. Ward

Bearfoot Teddy
Artist: Barbara Smith
Patron: Crown Center

Dr. K.C. Bear
Artist: Roger Garner
Patron: Thomas M. Johnson, M.D. Charitable Fund

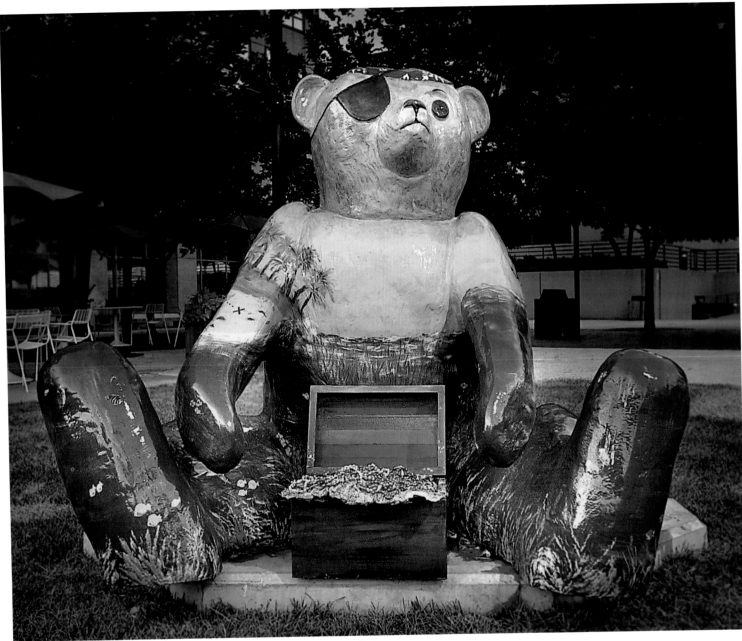

Bearied Treasure
Artist: Laura Lenhert
Patron: Executive Marketing Promotions, Inc.

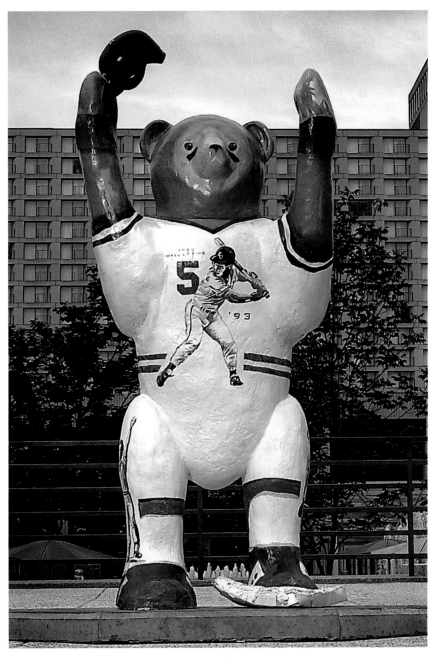

George Bear-ett
Artist: Sam Cangelosi
Patron: MAI Sports

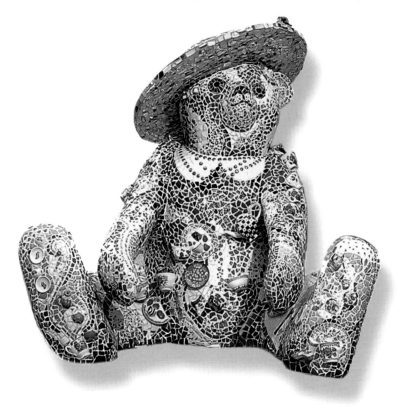

Bluebearry Tea Party
Artist: Susie Lawler
Patron: Friends of The Toy & Miniature Museum of Kansas City

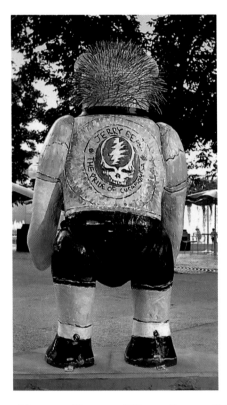

Jerry Bear, The Grateful Bear
Artist: Michael Savage
Patron: Crown Center

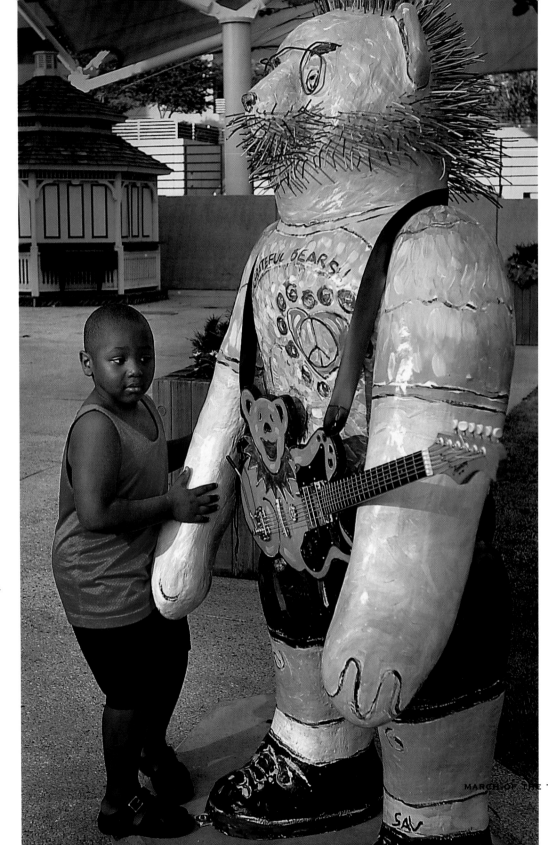

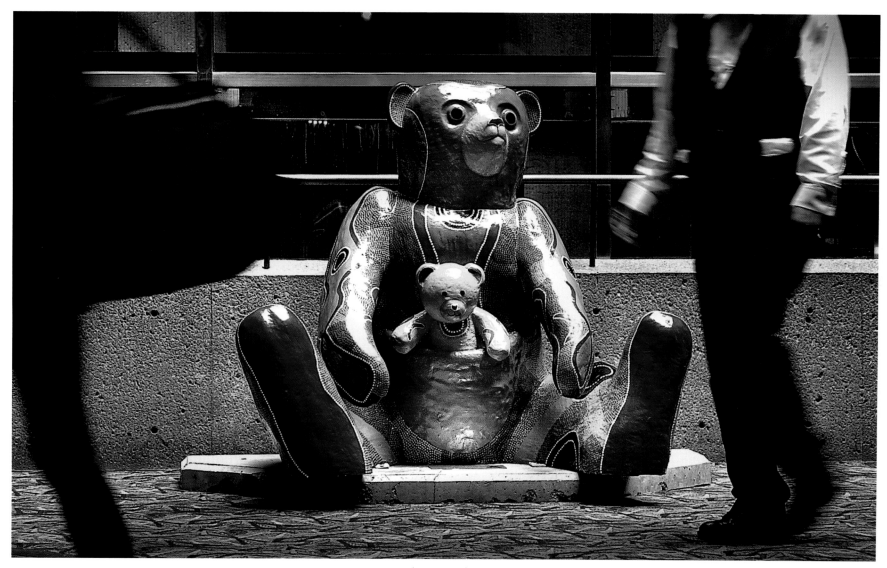

Kanga Bear
Artist: Lisa Pascolini
Patron: Crown Center

Peter Panda
Artist: Dave Fisher
Patron: Crown Center

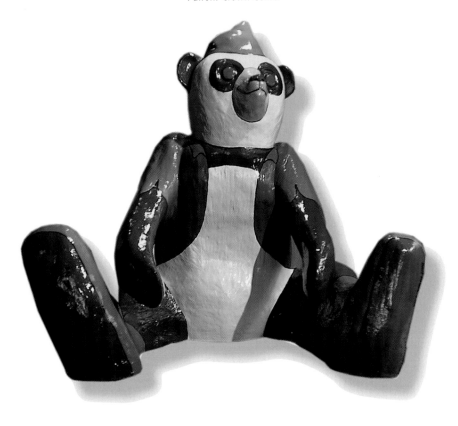

Safety & Security
Artist: Randy Harwerth
Patron: Schlage Lock Co.

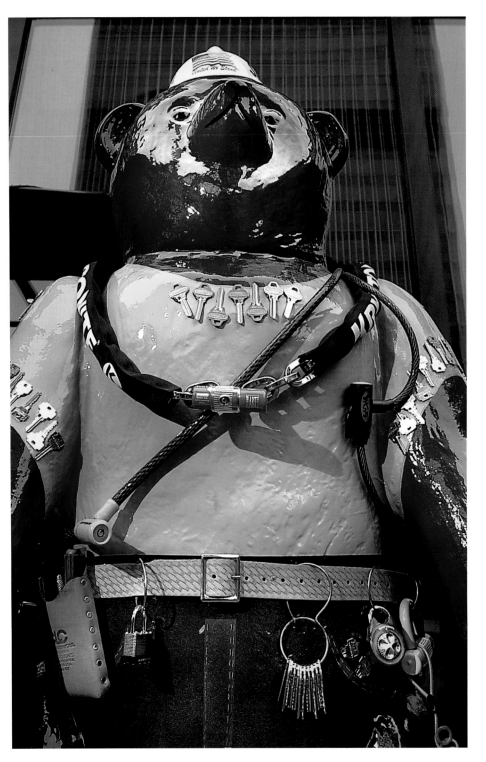

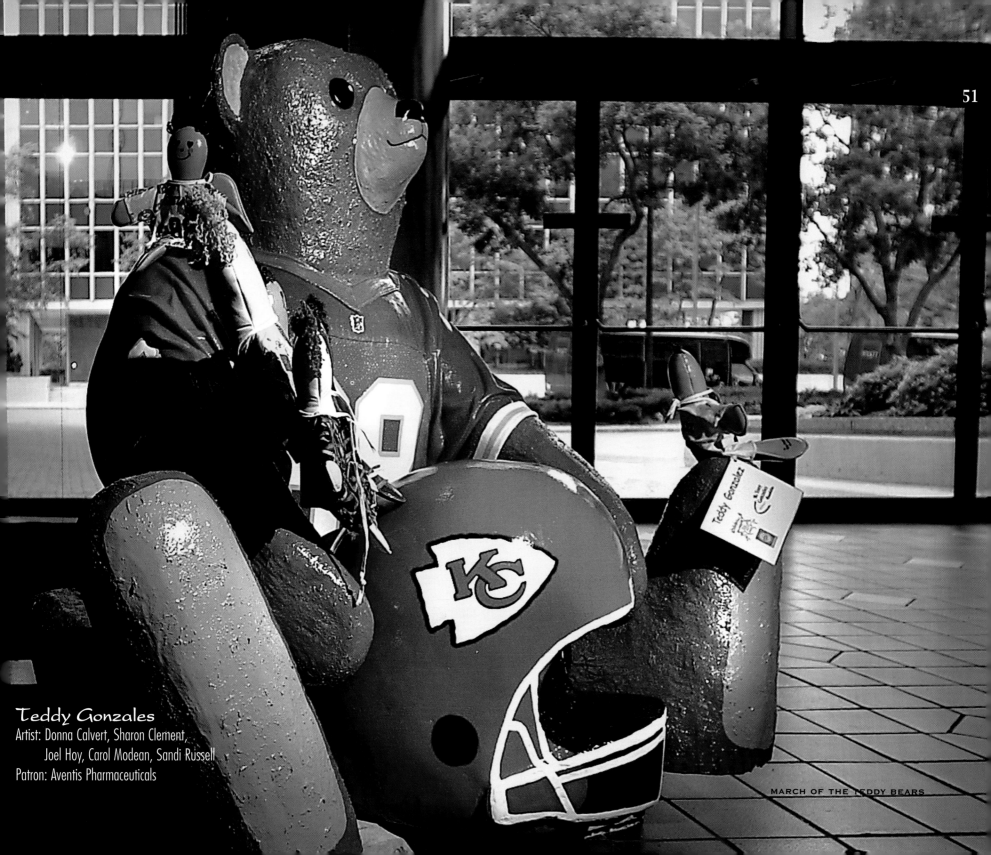

Teddy Gonzales

Artist: Donna Calvert, Sharon Clement,
Joel Hoy, Carol Modean, Sandi Russell
Patron: Aventis Pharmaceuticals

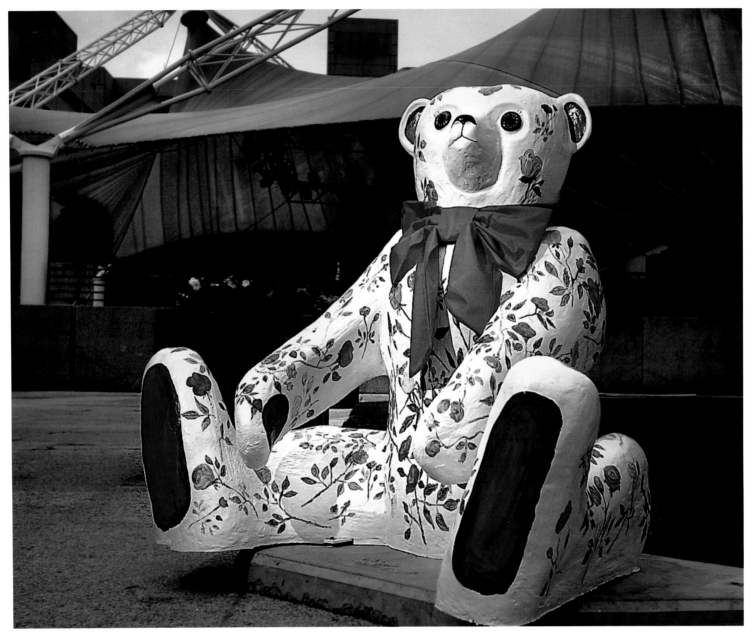

Teddy Rose-in-Bloom
Artist: Patricia Roney
Patron: Crown Center

The Honey Judge
Artist: Peggy A. Guest
Patron: The Kansas City Star

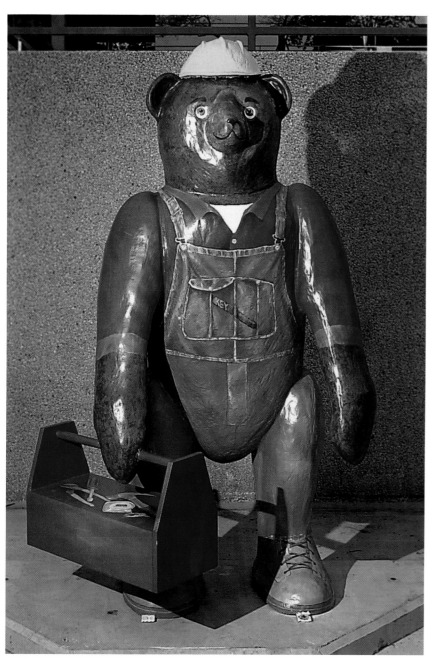

Bear the Builder
Artist: Justin Kruse
Patron: Friends of Children's Mercy Hospitals & Clinics

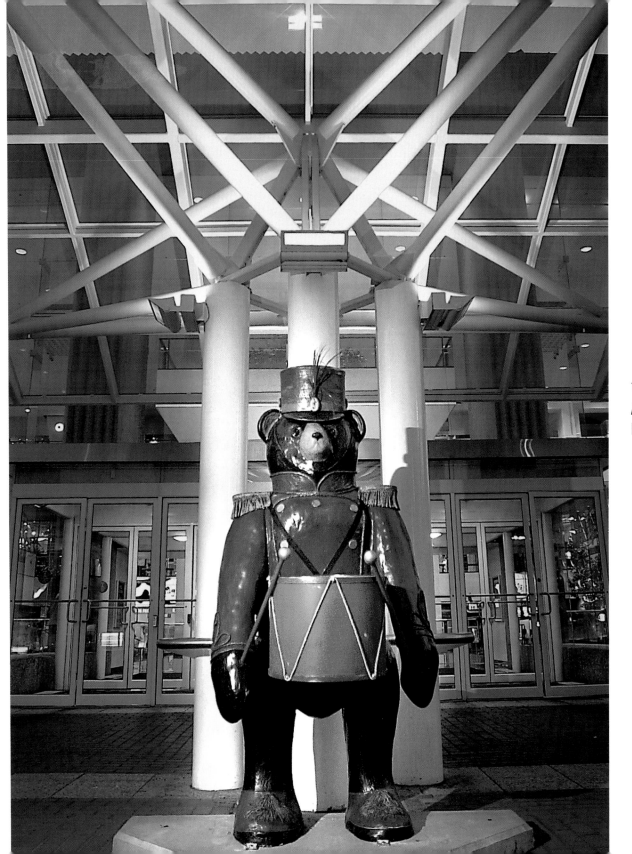

Wind-Up Tin Toy Teddy
Artist: Terri Sheldon-Merrill
Patron: Crown Center

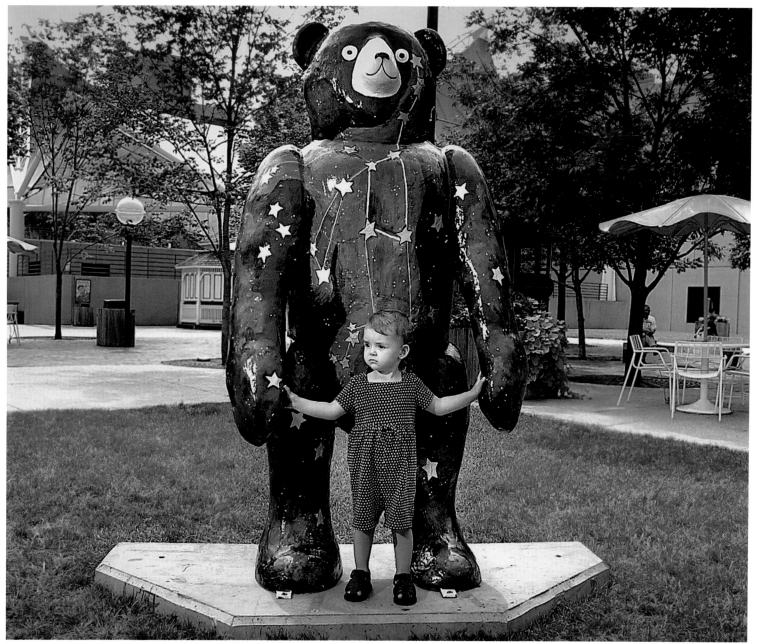

Ursa Major
Artist: Anita Toby
Patron: Crown Center

DEN 4

ILUS DAVIS PARK

Welcome to one of Kansas City's newest parks! Dedicated to the memory of the 48th mayor of Kansas City, the park is anchored on the north by the new Federal Courthouse and by City Hall on the south. It is symbolic of the continued renaissance of Kansas City's Downtown, but also Davis's central role in bridging the racial gap in Kansas City.

Davis was elected mayor of Kansas City in 1963 and served from then until 1971. He was considered a community builder and worked tirelessly to heal the racial divides that confronted the community during the '60s.

Here you will find one of the most popular bears in the March: "Huckle Bear," who appears to have just caught a fish out of the park's lake.

MARCH OF THE TEDDY BEARS

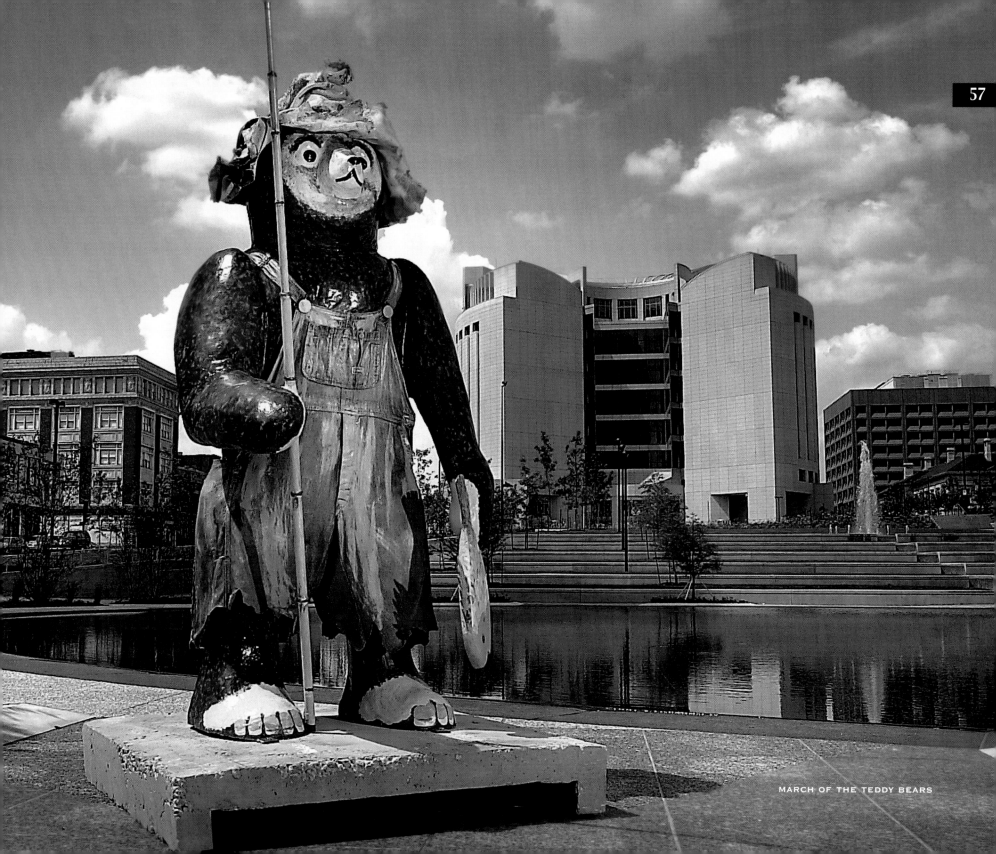

MARCH OF THE TEDDY BEARS

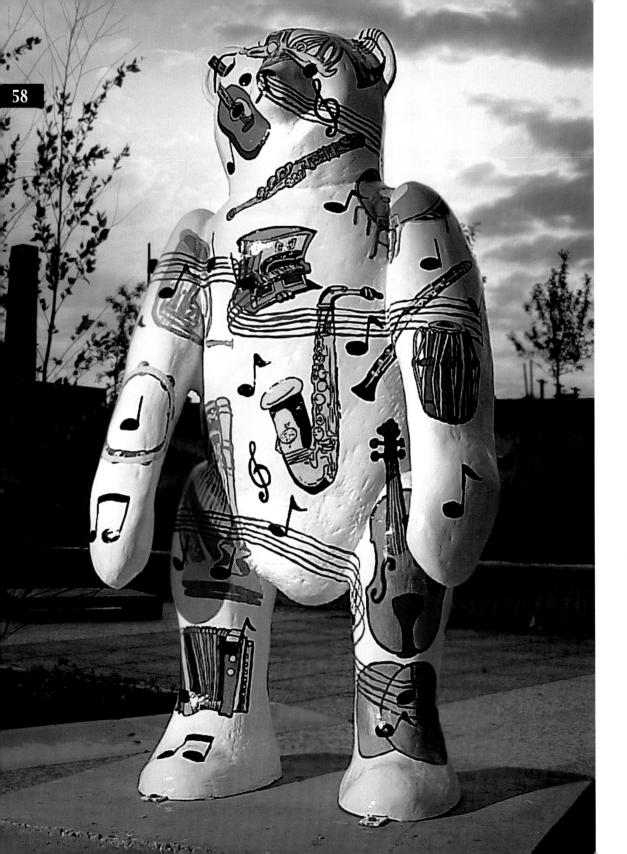

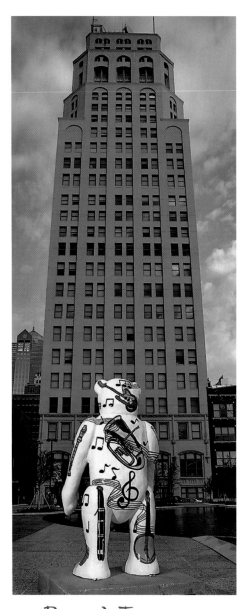

Bear-A-Tone
Artist: Donald Weeks, Sr.
Patron: City of Kansas City, Missouri

MARCH OF THE TEDDY BEARS

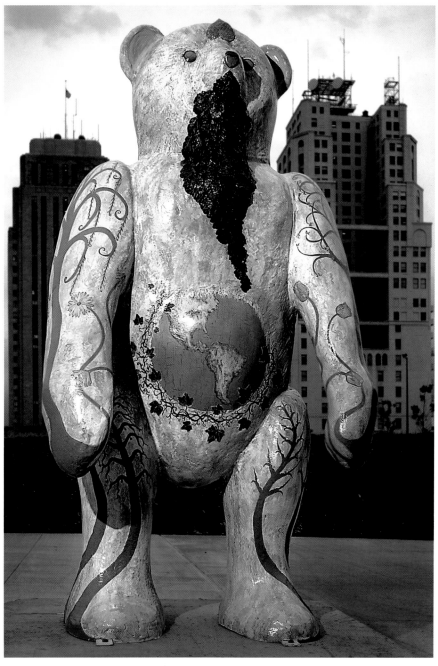

Green Bear
Artist: Sonja Foard
Patron: Kansas City, Missouri Parks and Recreation Dept.

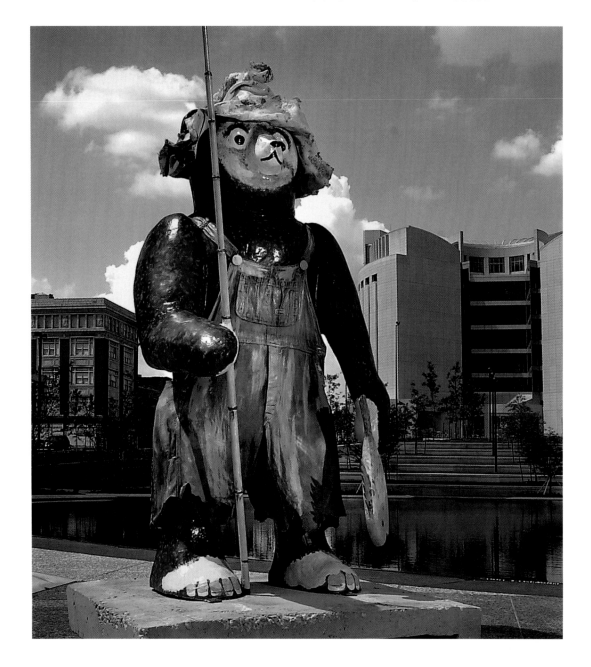

Huckle Bear
Artist: Herman A. Scharhag
Patron: Executive Marketing Promotions, Inc.

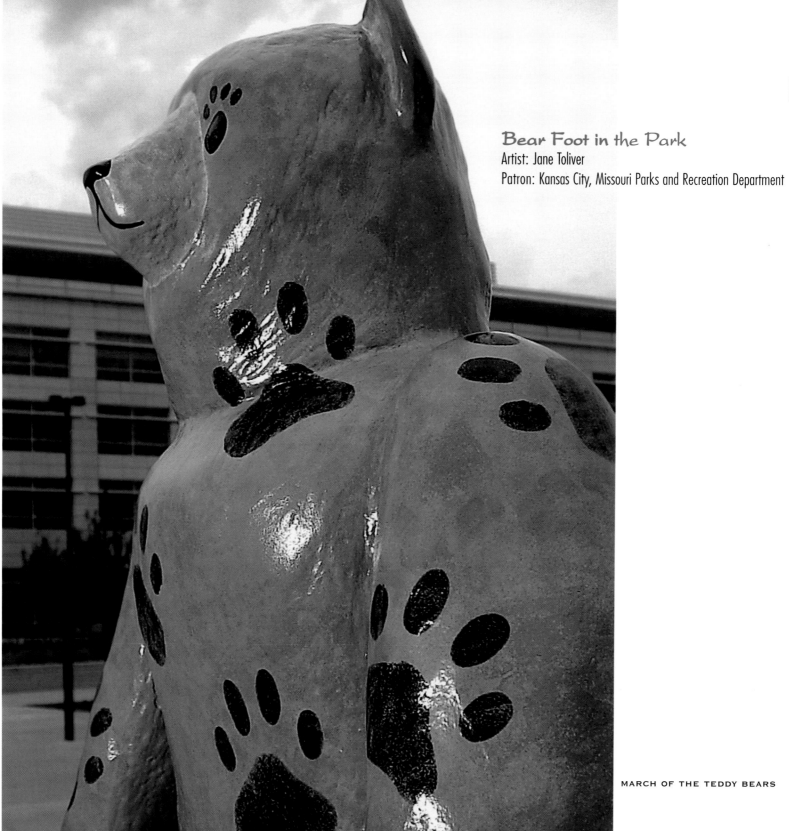

Bear Foot in the Park
Artist: Jane Toliver
Patron: Kansas City, Missouri Parks and Recreation Department

THE KANSAS CITY STAR

Kansas City's major metropolitan newspaper continues to build on the heritage established by its founder, William Rockhill Nelson. Nelson came to Kansas City in 1880 and vowed to publish a newspaper that would be a partner in the city's development.

Over time, Nelson would use *The Star* to push a number of initiatives, including paved streets, a stunning parks and boulevard system and bigger police and fire departments.

Today, nearly 1,600 employees of *The Star* work hard each day to produce the morning newspaper. Star offices are located downtown, in the surrounding suburbs and in Washington, D.C., and the Missouri and Kansas capitals.

MARCH OF THE TEDDY BEARS

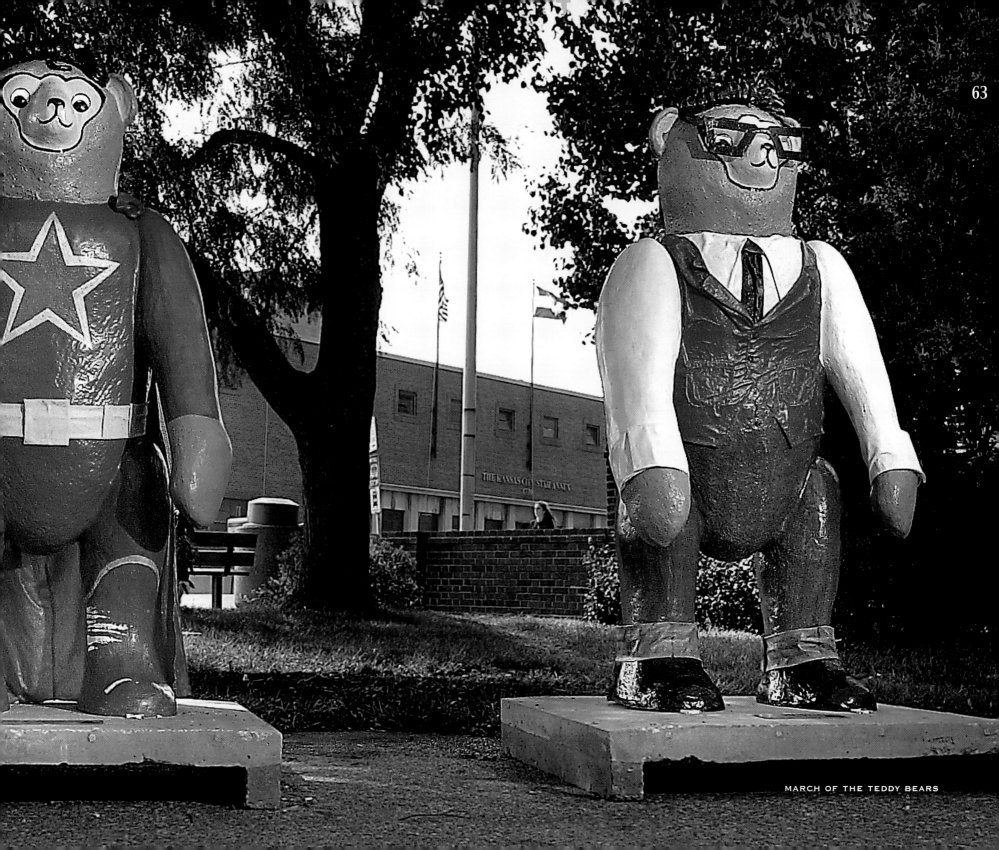

MARCH OF THE TEDDY BEARS

LEE'S SUMMIT, MISSOURI

Lee's Summit is a rapidly growing community of more than 70,000 just southeast of Kansas City. It ranks as the seventh largest city in Missouri in terms of population. In the 2000 Census, Lee's Summit was second in population growth in Missouri.

The city was founded in 1865 by William B. Howard, a successful farmer and stockman. He started the town with 70 acres of land and named it Strother (after his wife's maiden name). In 1867, the community had to be renamed, at the request of the U.S. Post Office, because there was already another existing town named Strother. The community was renamed and incorporated that same year as the Town of Lee's Summit.

The bears are located at Summit Woods, the newest shopping area in Lee's Summit built in response to the community's recent growth.

MARCH OF THE TEDDY BEARS

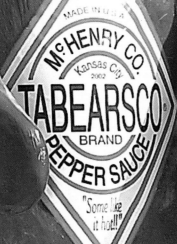

MARCH OF THE TEDDY BEARS

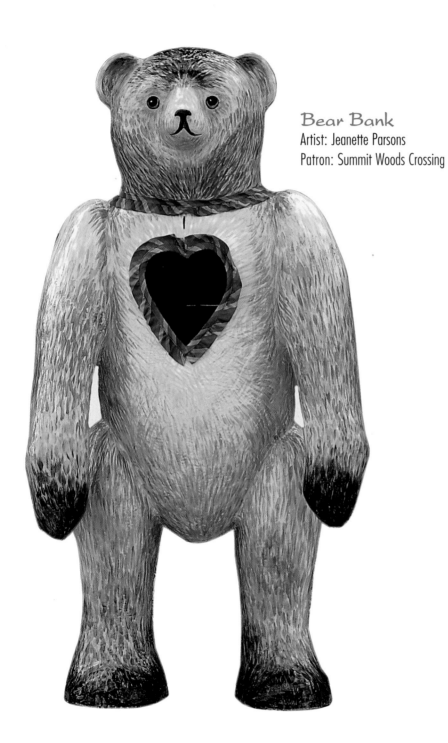

Bear Bank
Artist: Jeanette Parsons
Patron: Summit Woods Crossing

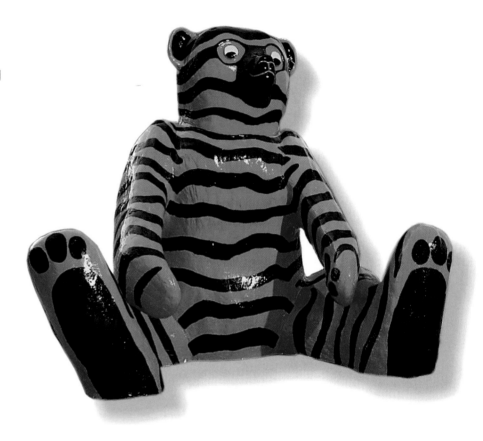

Tiger Bear
Artist: Santa Fe Trail Elementary Students
Patron: Friends of The Toy & Miniature Museum of Kansas City

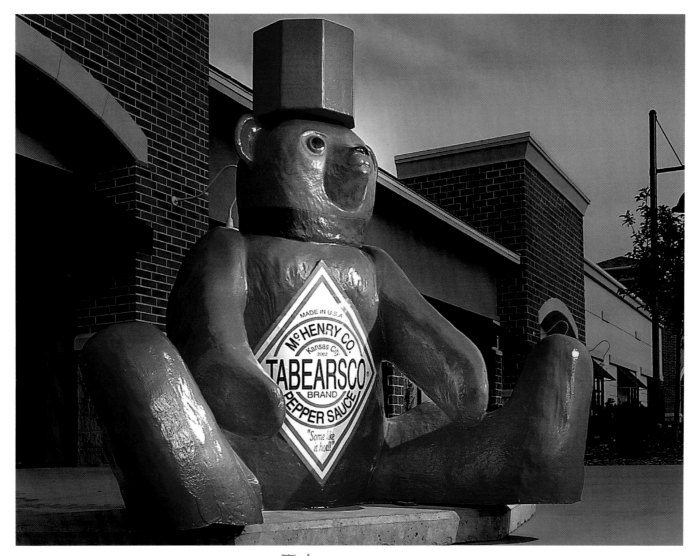

Tabearsco
Artist: Jeff DeRousse
Patron: The Kansas City Star

LIBERTY, MISSOURI

What began as a frontier trading post on the Missouri River in 1822 has blossomed into a thriving center of commerce and cultural activity.

The city's heritage dates back to the legendary Jesse James gang that once rode through the historic downtown square. Today, major interstates, both north to south and east to west, connect Liberty to the state and the rest of the country.

Residents enjoy many attractions — a symphony orchestra; civic theater; annual spring and fall festivals; three historical museums and the Clay County Archives. Plus William Jewell College. And now ... teddy bears!

MARCH OF THE TEDDY BEARS

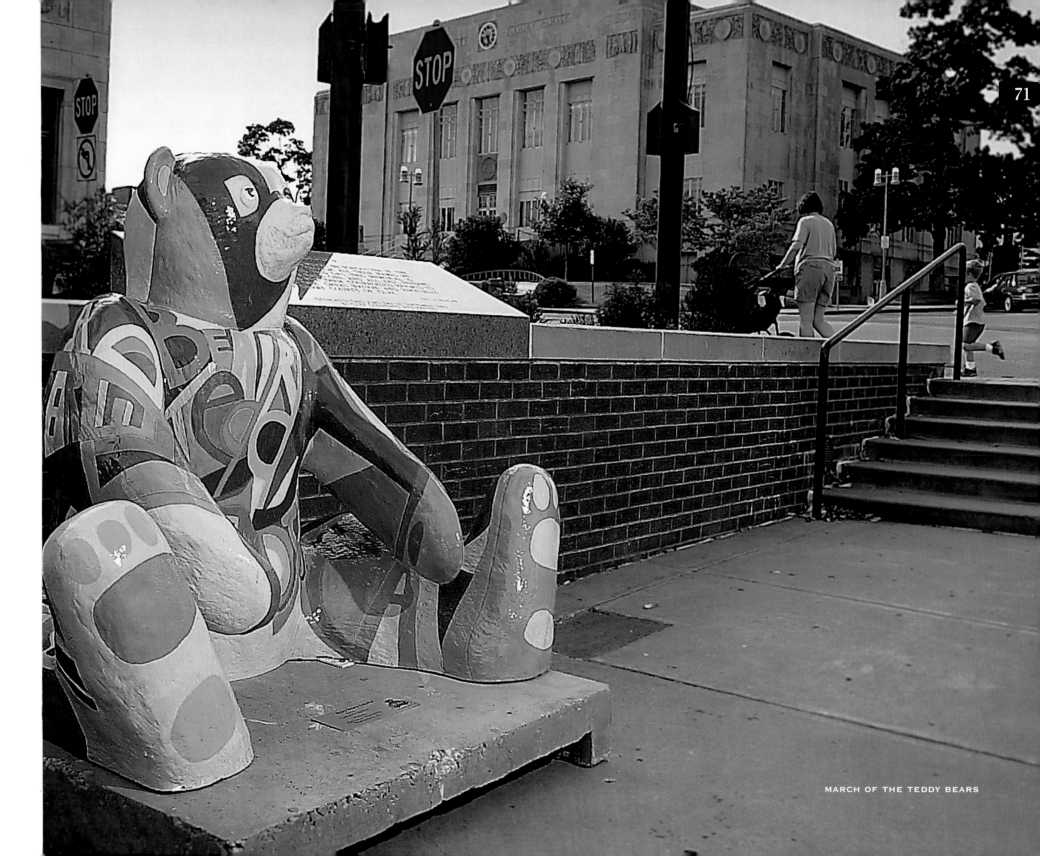

MARCH OF THE TEDDY BEARS

LINE CREEK PARK

Frank Vaydik Line Creek Park was established in 1967 as an archaeological preserve for an ancient campsite that now is listed on the National Register of Historic Places.

Historians think as many as four distinct Native American cultures passed through or inhabited sites along Line Creek to Riverside over several thousand years. The Hopewell Indians lived in this area from about 200 B.C. to A.D. 500.

The park, in addition to its archeology museum, includes a community center and miniature train — a fitting spot for K.C. Jones, the railroad bear!

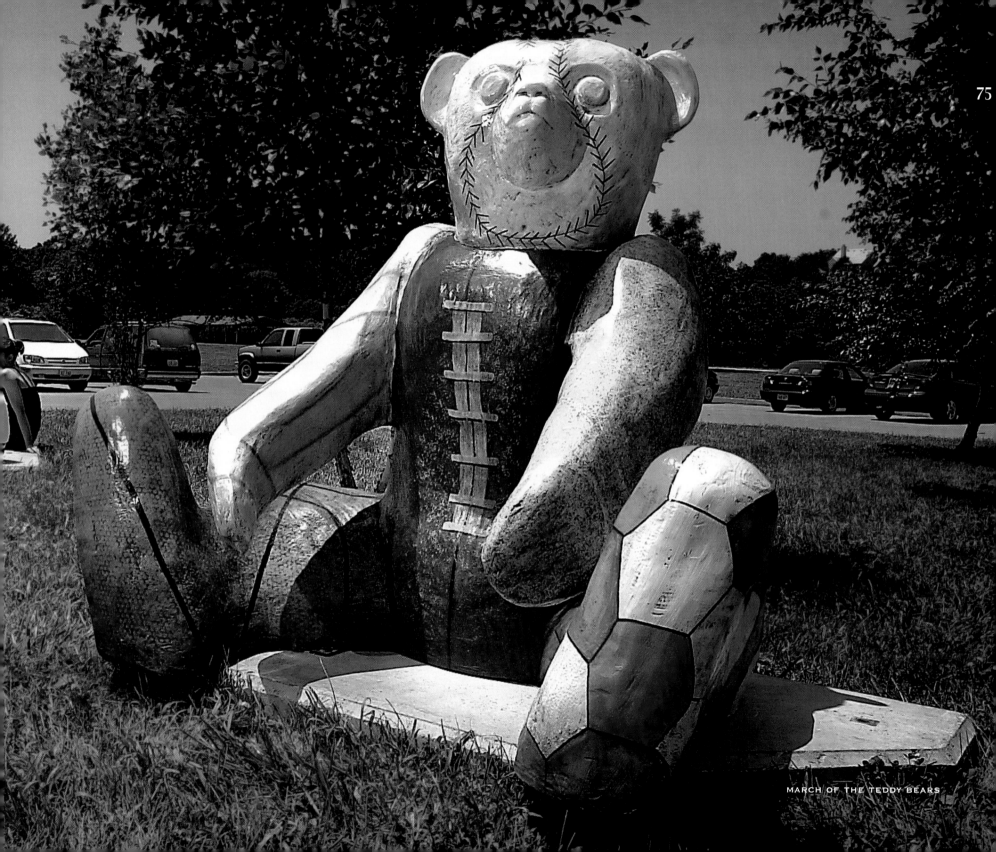

MARCH OF THE TEDDY BEARS

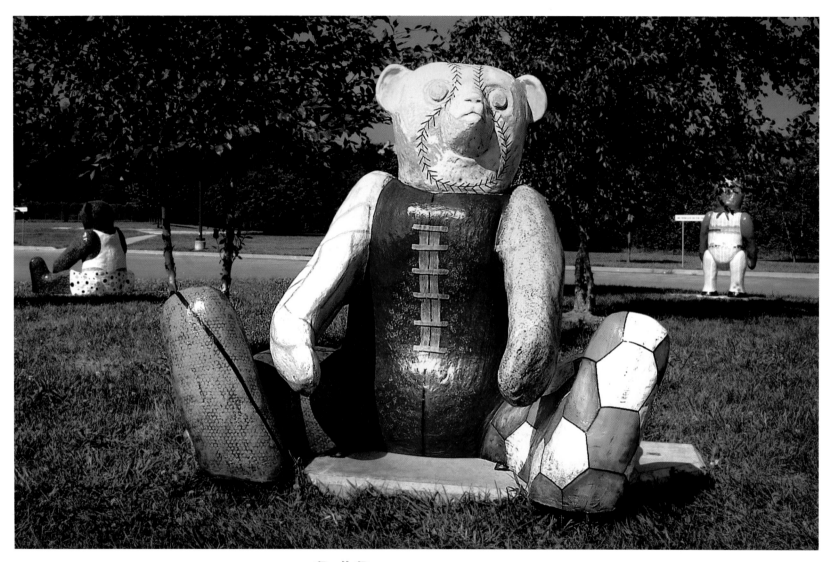

Ball Bear
Artist: Cindy DeGraw
Patron: Kansas City, Missouri Parks and Recreation Department

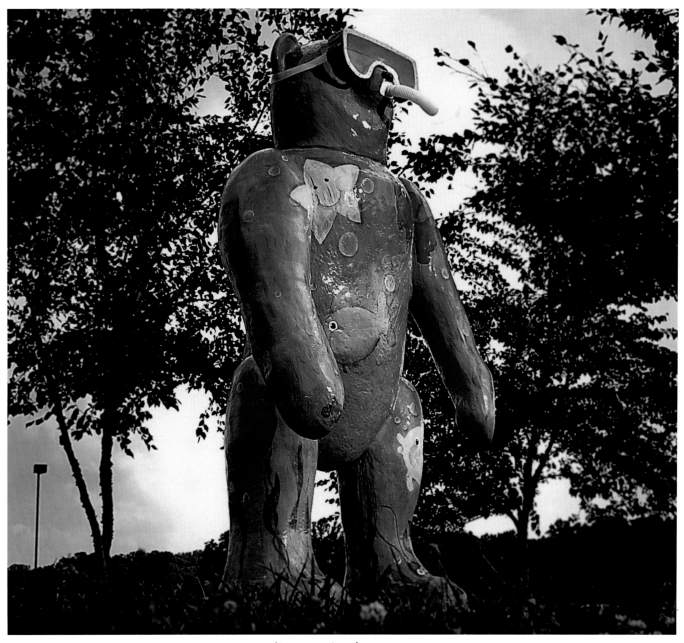

Beary Fishy
Artist: Second Nature Design Studio
Patron: The Kansas City Star

K.C. Jones
Artist: Kathleen A. Tacke
Patron: Kansas City, Missouri Parks
and Recreation Department

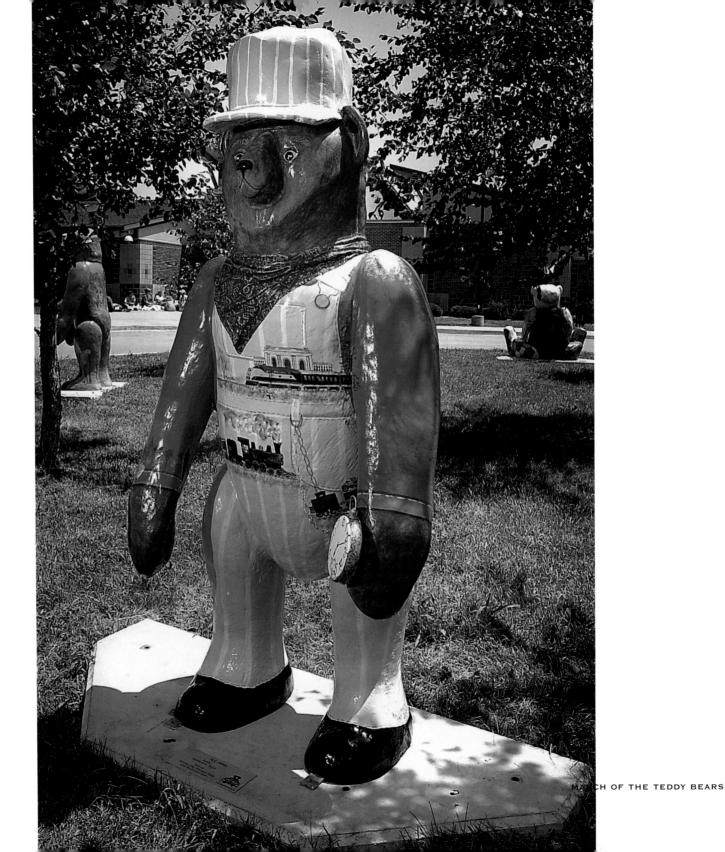

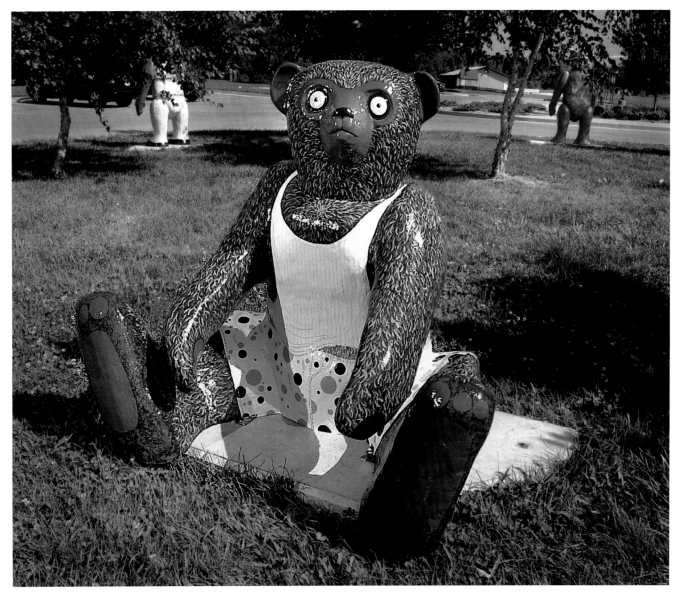

Under Bear
Artist: Cynthia Chilen
Patron: Hunt Midwest

LIBERTY MEMORIAL

Silent and dramatic, a restored Liberty Memorial again stands proud. In a burst of spirit, Kansas Citians gave their nickels, dimes and dollars to build the monument in 1926. Decades later, they arose again to preserve Liberty for future generations, and the new and improved Liberty Memorial was rededicated in 2002.

To honor that rededication, the March of The Teddy Bears created five special bears to symbolize the allies who fought to victory in World War I. Those nations — Belgium, France, Italy, United Kingdom and the United States — are well represented as the bears stand guard over the refurbished memorial.

MARCH OF THE TEDDY BEARS

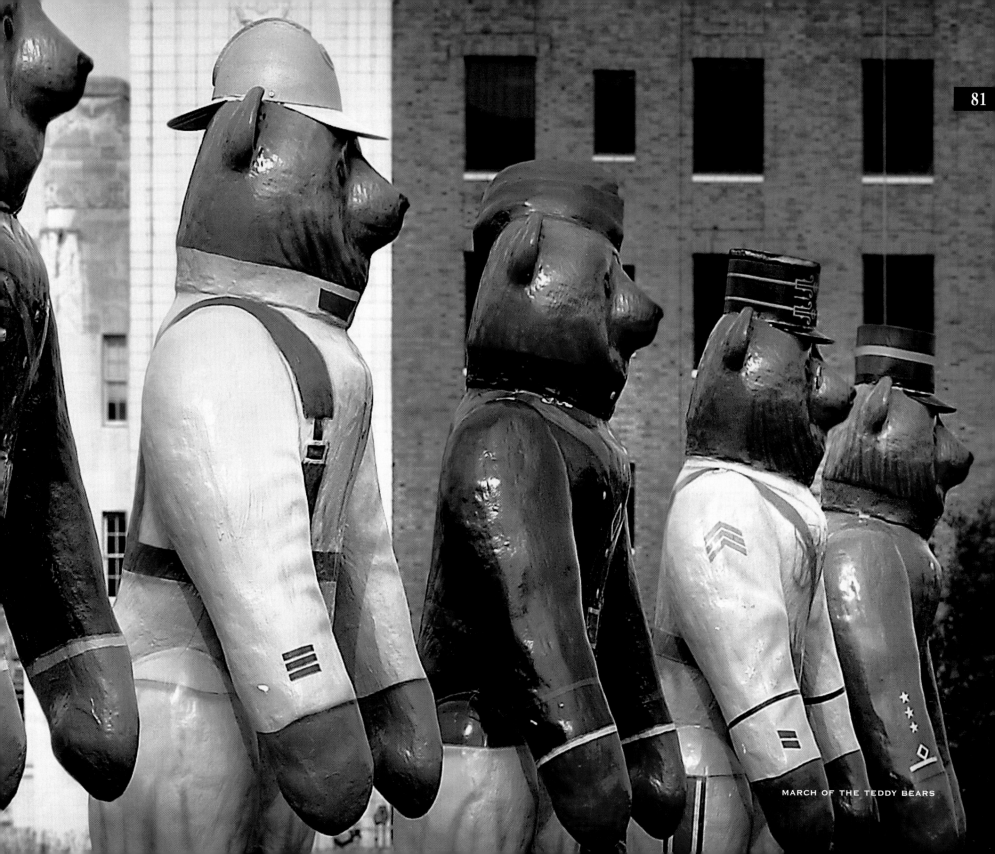

MARCH OF THE TEDDY BEARS

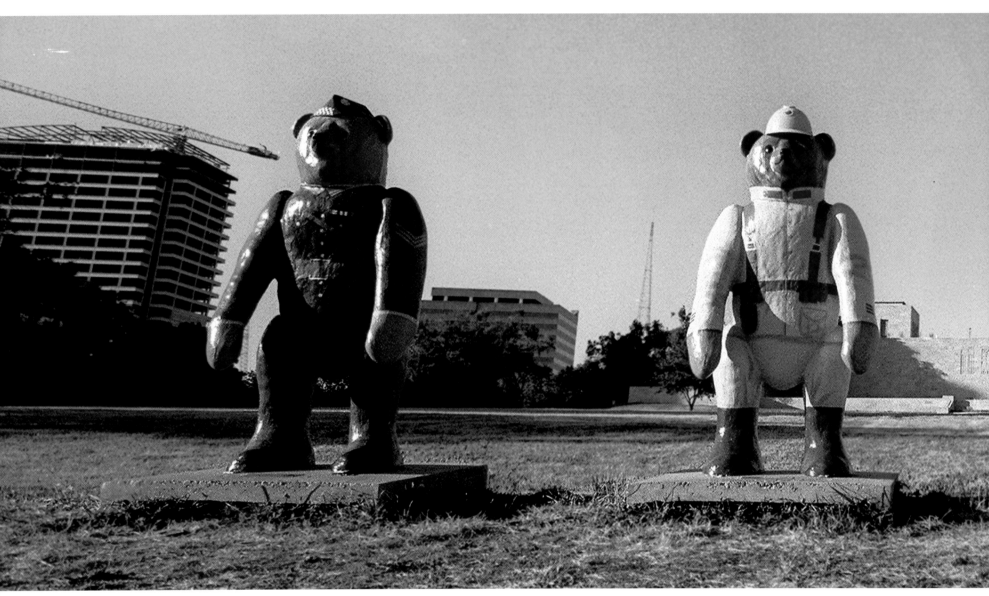

United Kingdom Bear

Belgium Bear

Artist: Tim Cox & Adam Guard
Patron: March of the Teddy Bears

MARCH OF THE TEDDY BEARS

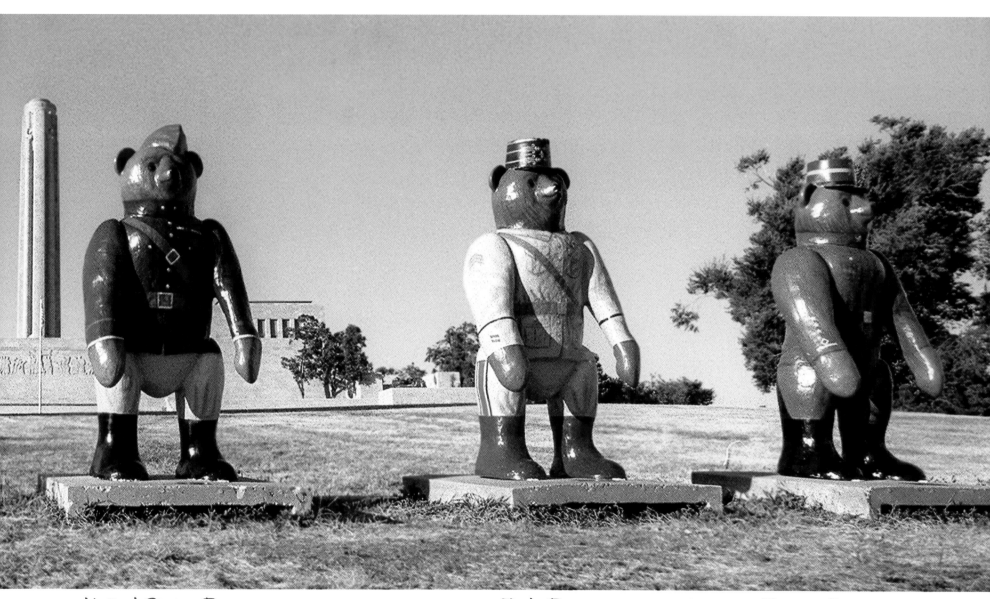

United States Bear Italy Bear France Bear

Artist: Tim Cox & Adam Guard
Patron: March of the Teddy Bears

MILL CREEK PARK

This Kansas City park, located just east of the Country Club Plaza, is a favorite of lunch-time walkers for its proximity to nearby offices, shops and the famed J.C. Nichols Memorial Fountain.

The fountain is the best-known and most-photographed of all of the city's fountains. It features four horses that are said to represent four rivers — the Mississippi, the Volga, the Seine and the Rhine.

The sculptures were created in the early 1900s and resided on Long Island, New York, until they were refurbished and moved to Kansas City in 1960.

MARCH OF THE TEDDY BEARS

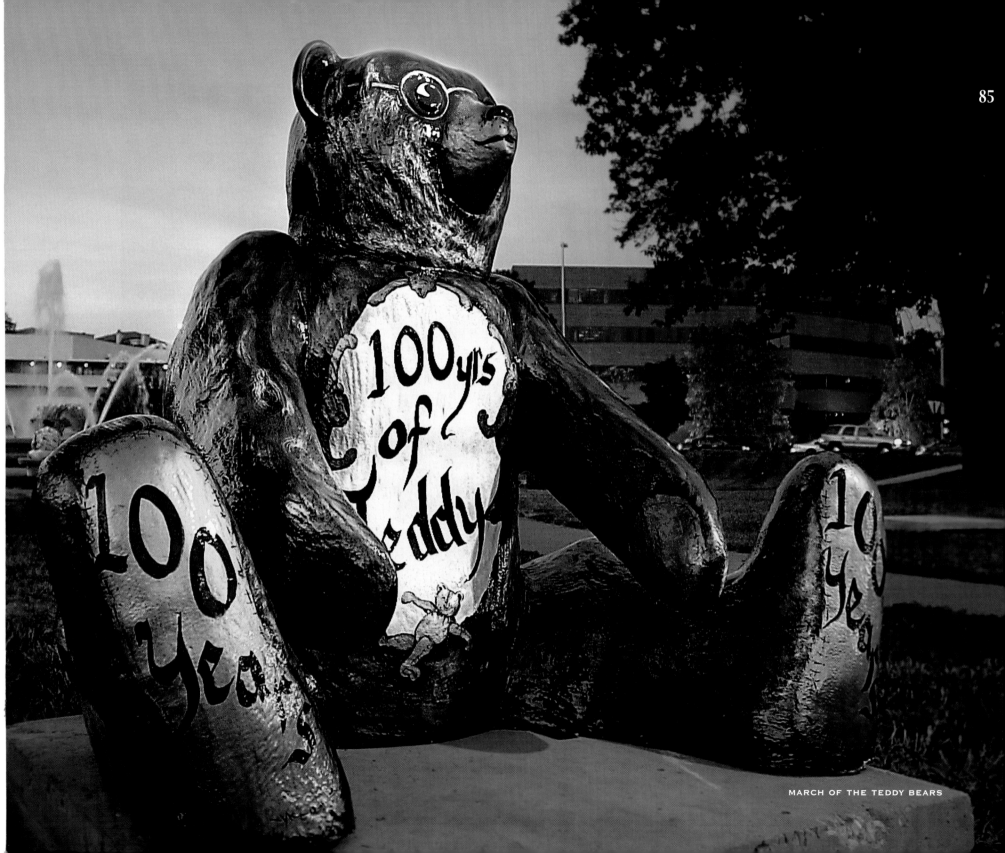

MARCH OF THE TEDDY BEARS

DEN 11

Starlight Theatre

Starlight Theatre is Kansas City's largest and oldest performing arts organization and is the second largest theatre of its kind in the United States. It was founded in 1950 and is now in its 52nd season.

The theatre has been named "Best Entertainment Venue" and "Best Performing Arts Venue" in Kansas City by *Ingram's* magazine and "Best Live Musical Theatre" by *Kansas City* magazine.

Here are bears with a showbiz bent — "Some Like It Hot," "Bearymore of Broadway," "Les Miserables" and more.

MARCH OF THE TEDDY BEARS

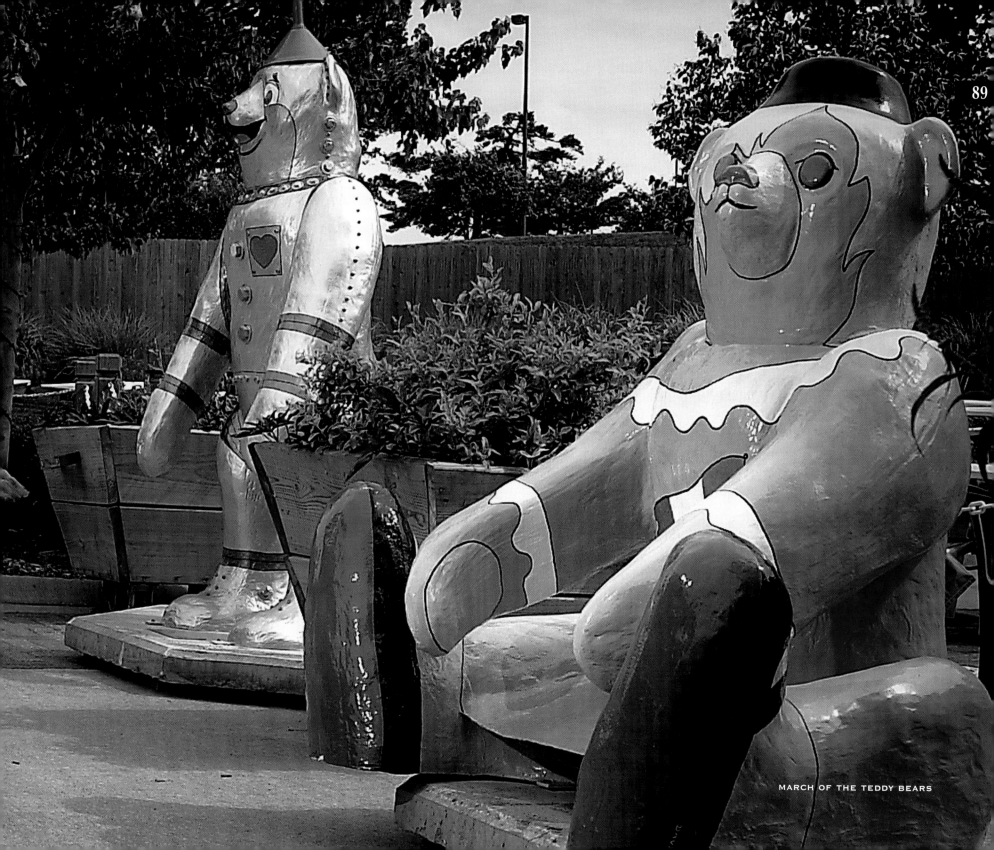

MARCH OF THE TEDDY BEARS

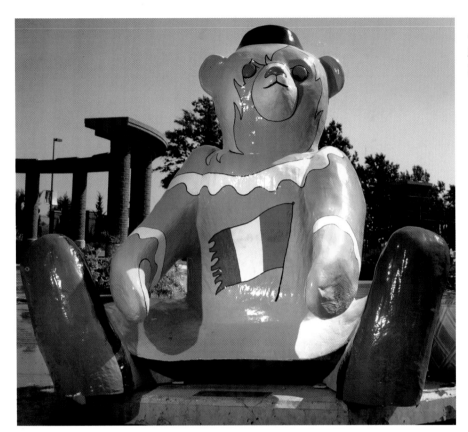

Les Miserables
Artist: Dave Fisher
Patron: Starlight Theatre

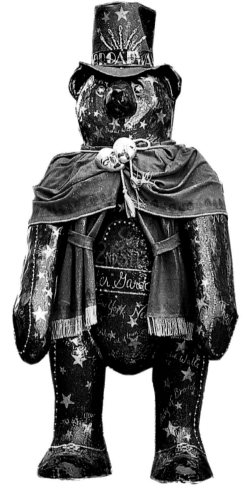

Bearymoor of Broadway
Artist: Judy Tuckness
Patron: Chuck & Joan Battey

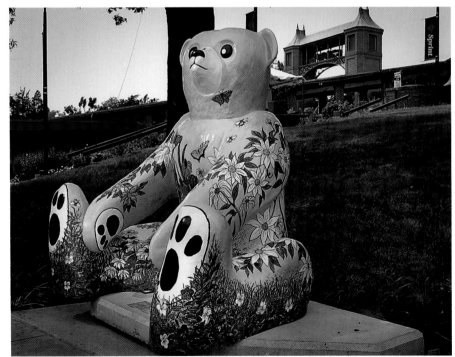

From Bear Ground Spring Flowers
Artists: Johnson County K-State Extension Master Gardeners
Sponsor: Bill and Carlene Hall

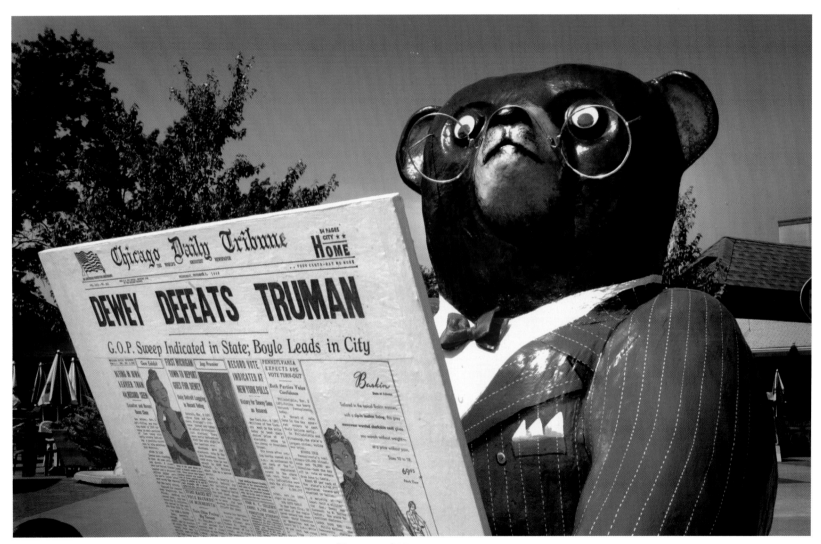

Beary Truman
Artist: Vicki Williams
Patron: Taylor Cable Products, Inc.

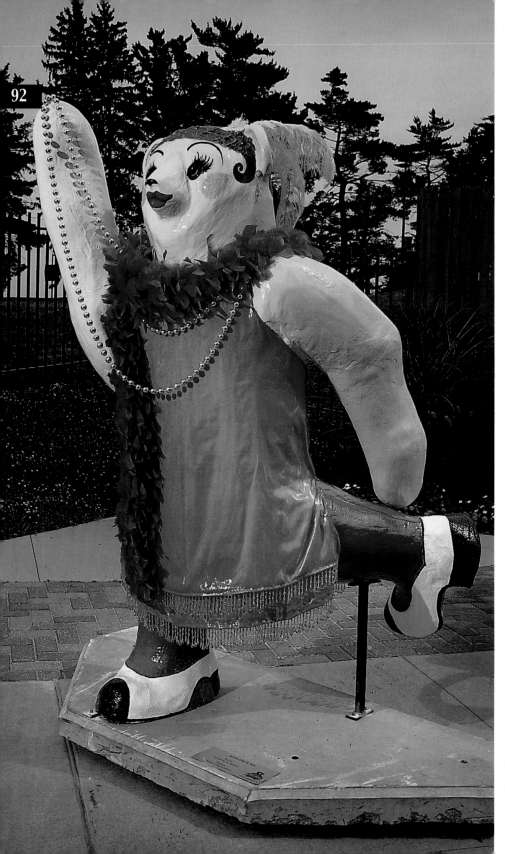

Some Like It Hot
Artist: Susanne Andersen
Patron: Bayer Corporation

STARLIGHT THEATRE

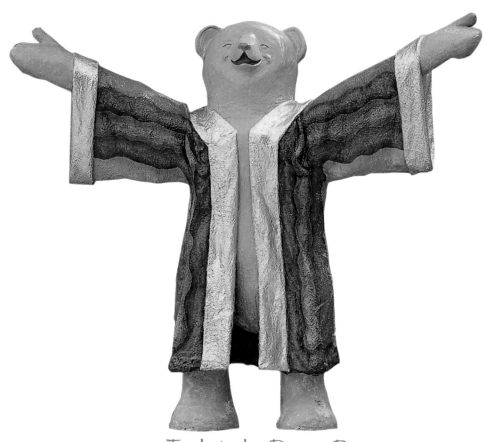

Technicolor Dream Bear
Artist: Marcella Smith
Patron: Starlight Theatre

MARCH OF THE TEDDY BEARS

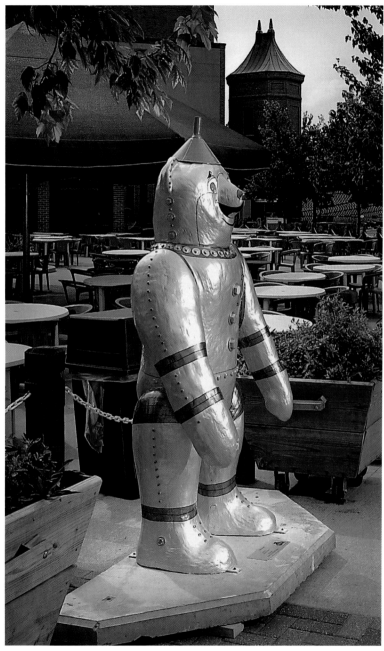

Tin Bear
Artist: Dave Fisher
Patron: Keith & Margi Pence

Wish Upon the Stars
Artist: Jane McWilliams
Patron: Steadman Family Foundation

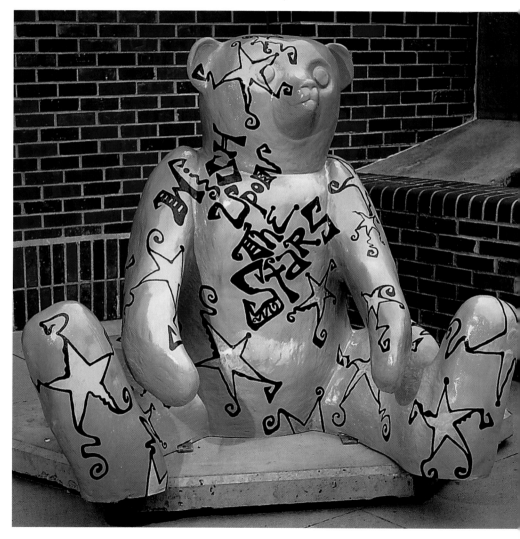

Town Center Plaza

Town Center Plaza is the prestige retail address of the city of Leawood. Built on the burgeoning 119th Street corridor, Town Center boasts a mix of regional and national retailers, restaurants and other businesses.

The center is a reflection of the rapid growth Leawood has seen in recent years. Leawood was incorporated in 1948 with slightly more than 1,000 inhabitants. The city now boasts more than 27,000 residents. Since 1992, Leawood has had one of the fastest-growing populations in the state of Kansas.

MARCH OF THE TEDDY BEARS

MARCH OF THE TEDDY BEARS

96 98

Hide-n-Seek Bear
Artists: Julie Koonse Sturm & Terri Schrader
Patron: The Learning Tree

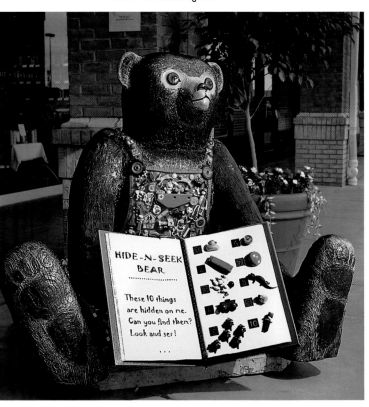

Some Like Jt Hot in Kansas
Artist: Kristin Dempsey
Patron: The Kansas City Star

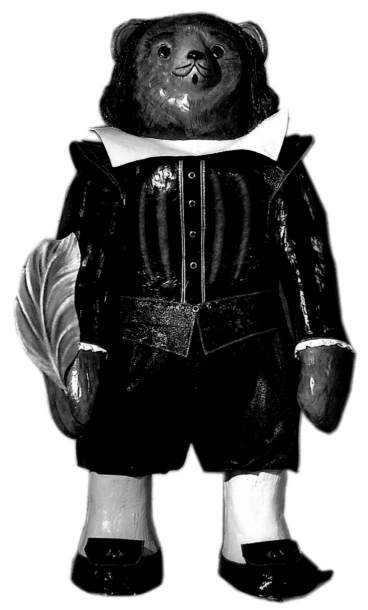

William Shakesbear
Artist: Liberty Christian Fellowship to Haiti
Patron: Town Center Plaza

Let's Go to the Movies
Artist: Julie Murphy
Patron: Dickinson Theatres

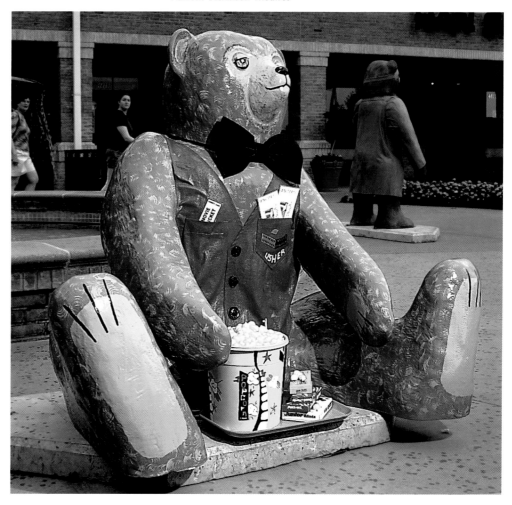

TOY & MINIATURE MUSEUM

The Toy and Miniature Museum of Kansas City was founded in 1982 by two Kansas Citians — Mary Harris Francis and Barbara Marshall.

Located on the campus of the University of Missouri-Kansas City, the museum contains 24 rooms filled with antique dolls, dolls' houses, cast iron toys, trains, and scale miniatures.

The museum, which features some of the most colorful bears in The March of the Teddy Bears, is one of the beneficiaries of the March's fund-raising.

MARCH OF THE TEDDY BEARS

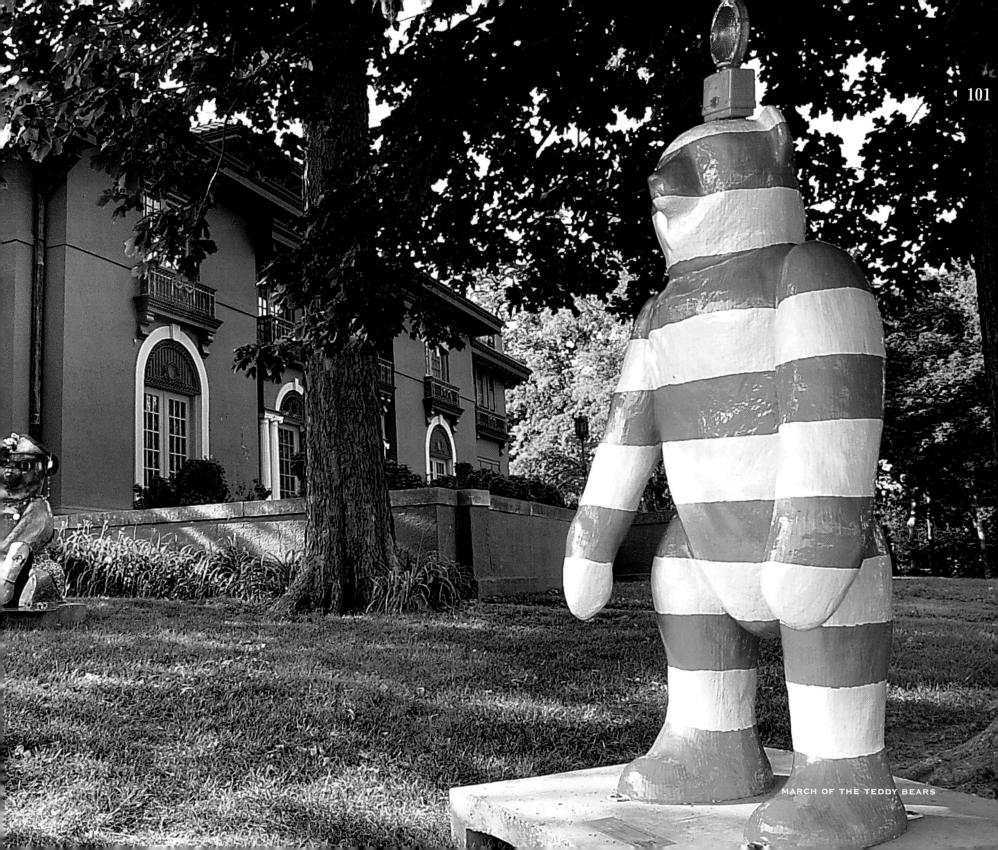

MARCH OF THE TEDDY BEARS

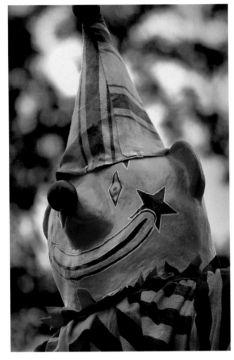

Bearly Balanced Bearnini's
Artists: Judy & Don Tuckness
Patron: Francis Families Foundation

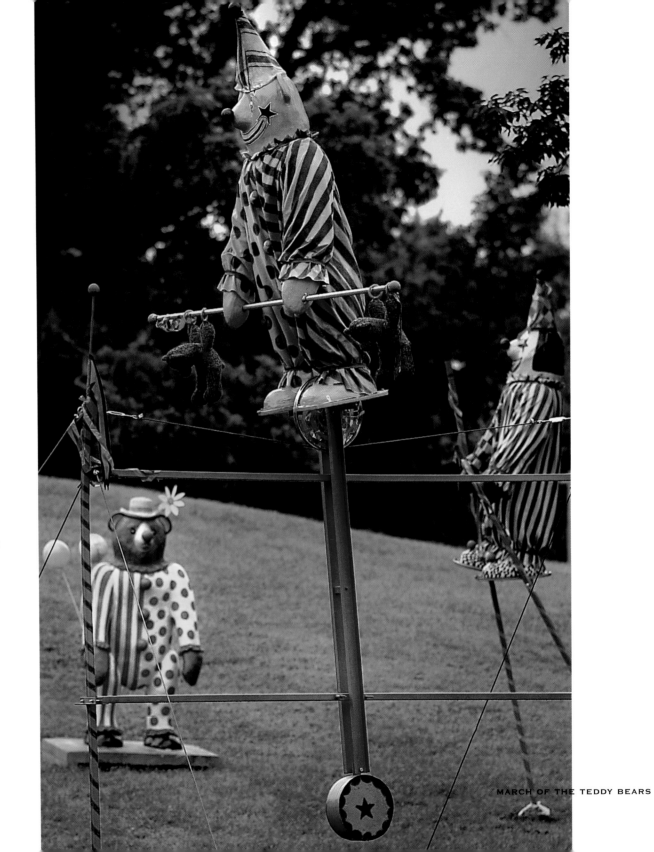

MARCH OF THE TEDDY BEARS

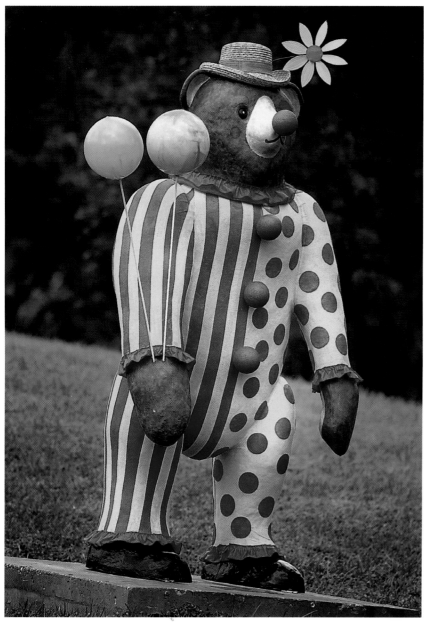

Bozo Bear
Artist: Jane Toliver
Patron: Francis Families Foundation

Construction Bearrel
Artist: Suzannah Frisbie
Patron: Francis Families Foundation

Honey Bee Bear
Artist: Sandra Russell
Patron: Francis Families Foundation

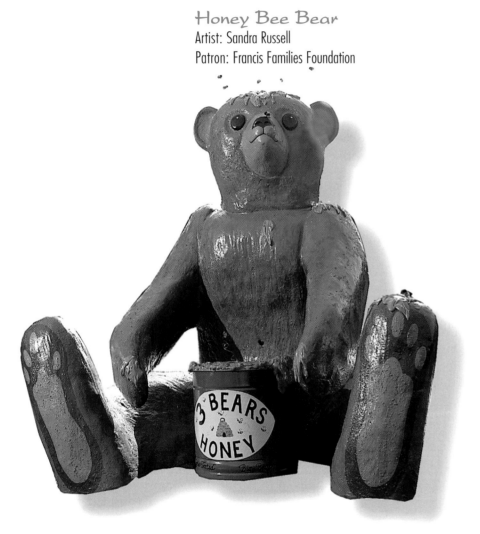

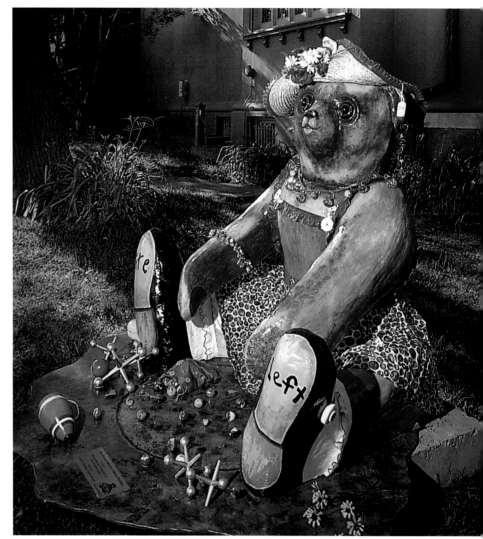

Marbleous Minnie's Many Marbles
Artist: Moon Marble Company & The Marble Lady
Patron: Francis Families Foundation

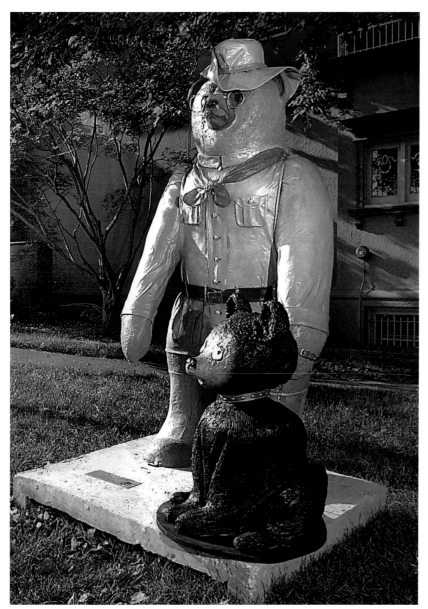

Theo-Bear Roosevelt
Artist: Judy Tuckness
Patron: Friends of The Toy & Miniature Museum of Kansas City

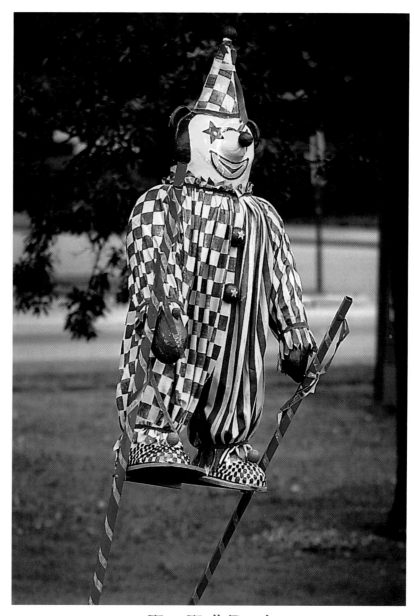

Too Tall Pawl
Artists: Judy & Don Tuckness
Patron: Francis Families Foundation

DEN 14

UNION STATION

Built in 1914, Union Station served as an important link in cross-continental travel during the glory days of rail traffic.

In 1917, railway traffic peaked at Union Station with more than 79,000 trains passing through. But soon after, travel by train began to decline, and consequently, so did the condition of Union Station. But 80 years later, thanks to a unique idea in Science City and the approval of a bi-state tax, Union Station is once again one of Kansas City's biggest attractions.

MARCH OF THE TEDDY BEARS

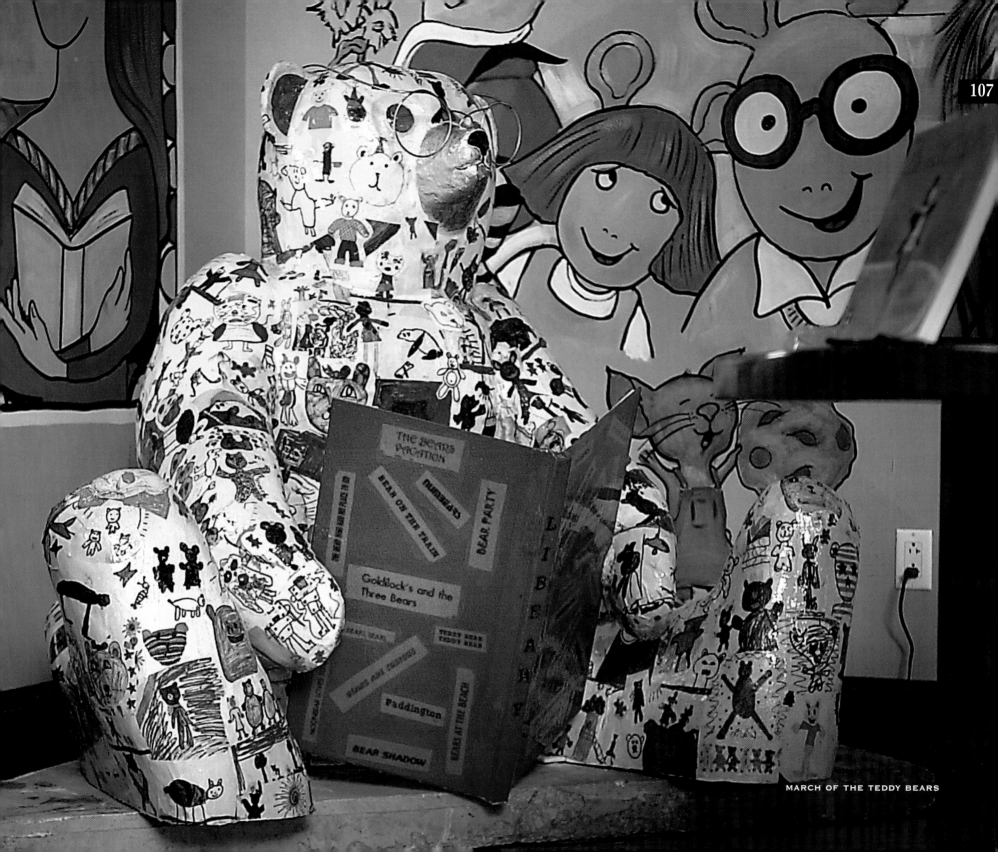

MARCH OF THE TEDDY BEARS

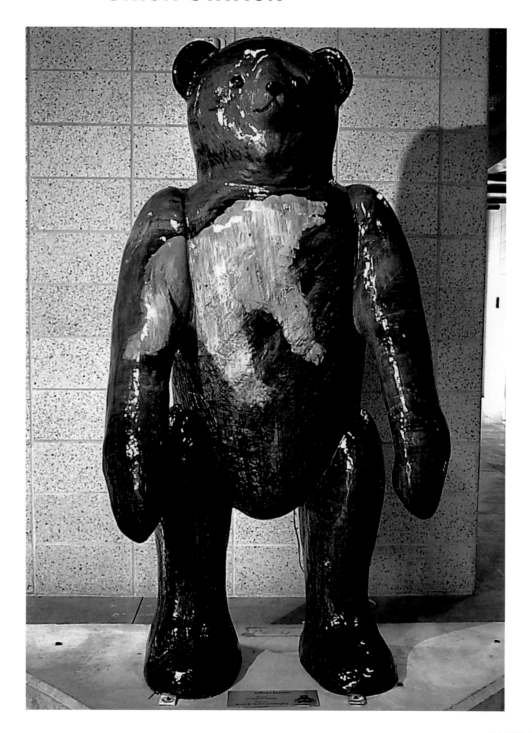

AuRoara Bearealis
Artist: Cheryl Simmons
Patron: James B. Nutter & Company

Classical Cookie Jar
Artist: Jeff DeRousse
Patron: The Kansas City Star

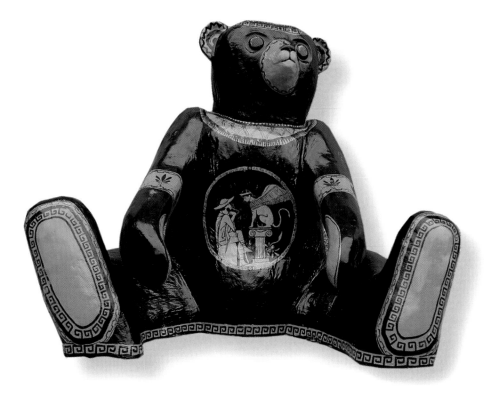

Beary Good Day to be a Kid
Artist: Kristin Dempsey
Patron: James B. Nutter & Company

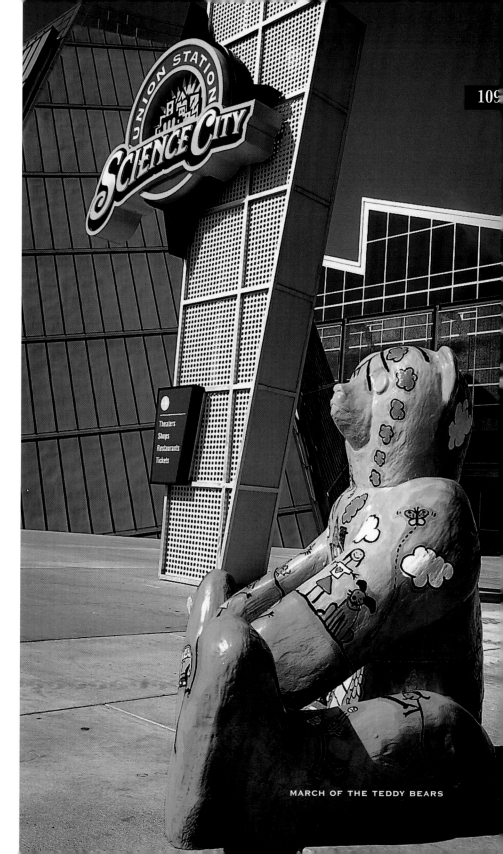

MARCH OF THE TEDDY BEARS

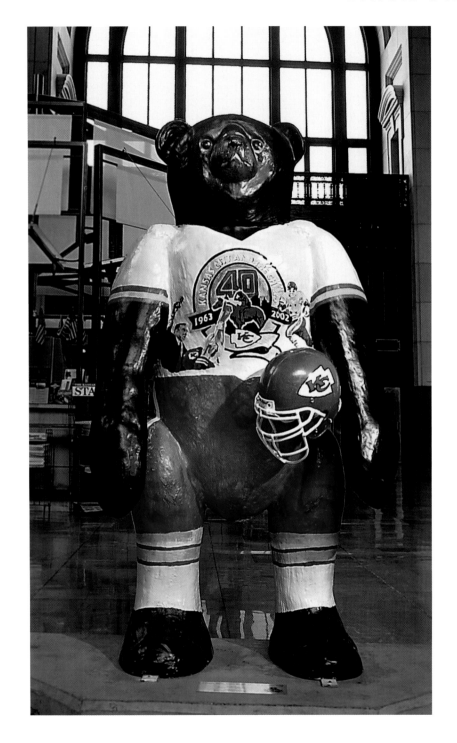

Chiefs 40th Anni-BEAR-sary in Kansas City
Artist: Sam M. Cangelosi
Patron: Kansas City Chiefs

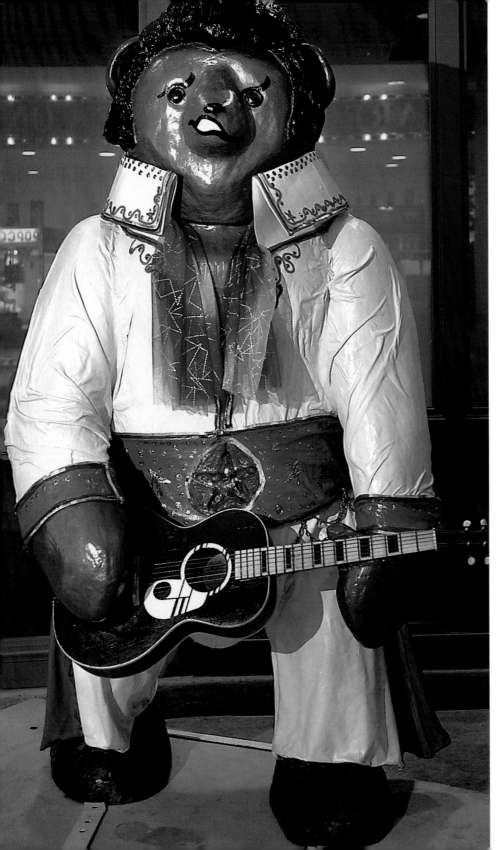

Elvis Bearsley
Artists: Geri Stewart and Alicia Scott
Patron: James B. Nutter & Company

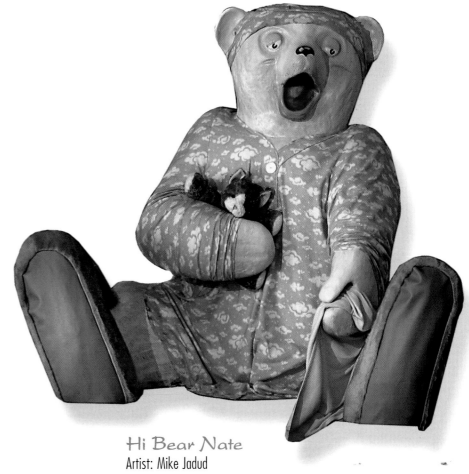

Hi Bear Nate
Artist: Mike Jadud
Patron: James B. Nutter & Company

MARCH OF THE TEDDY BEARS

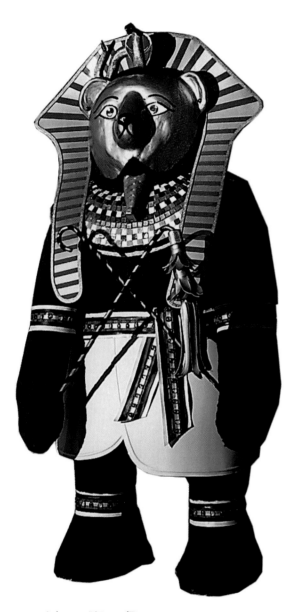

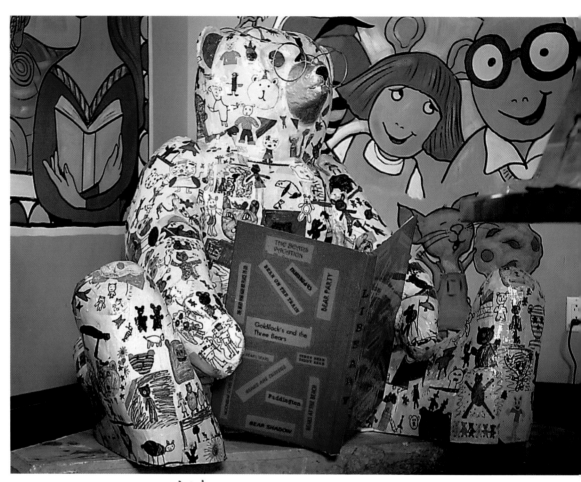

Li-bear-y
Artist: Janet Watkins
Patron: Friends of The Toy & Miniature Museum of Kansas City

King Tut Bear
Artist: Sophia Myers
Patron: Friends of The Toy & Miniature Museum of Kansas City

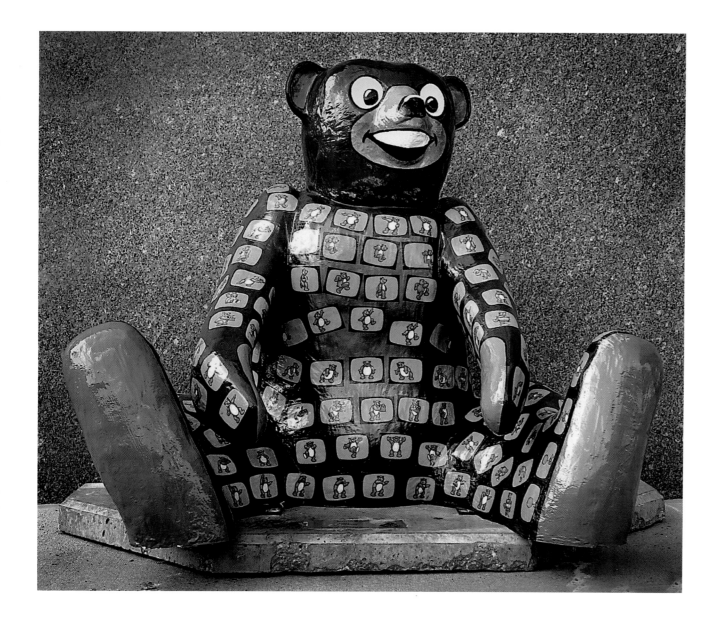

Marching Teddies
Artist: Ron Wheeler
Patron: Video Post Productions

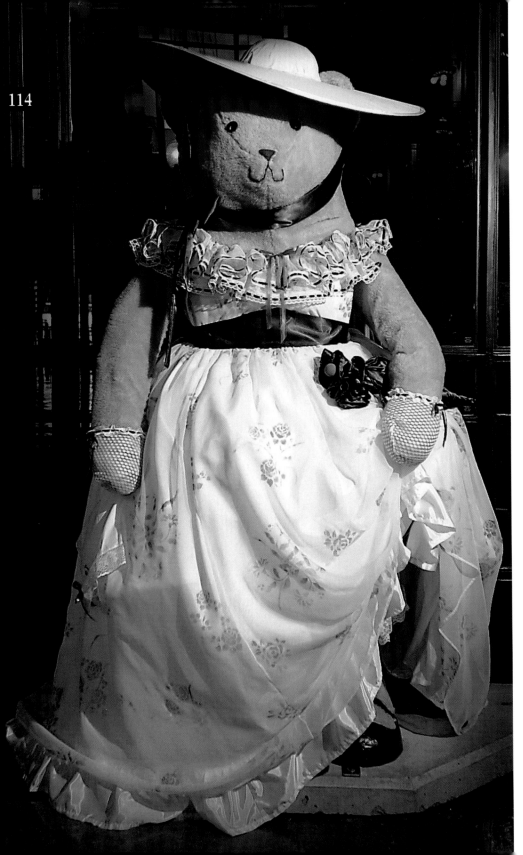

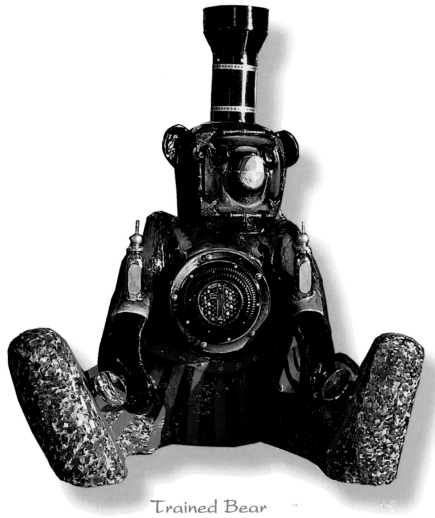

Trained Bear
Artist: Cindy DeGraw
Patron: Friends of The Toy & Miniature Museum of Kansas City

Scarlet O'Beara
Artist: Teresia Harding
Patron: James B. Nutter & Company

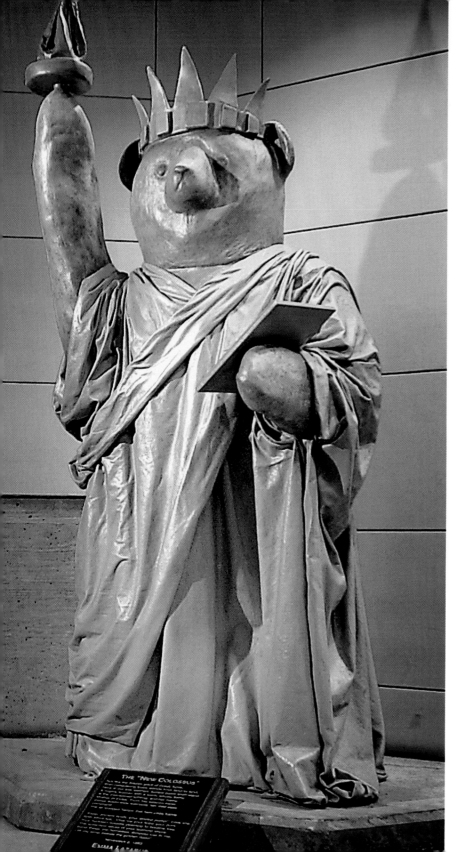

Statue of Li-bear-ty
Artist: Megan Hendrix
Patron: James B. Nutter & Company

A Beary Good Question
Artist: Patricia Roney
Patron: James B. Nutter & Company

WASHINGTON SQUARE PARK

With its statue of George Washington on horseback towering over an expanse of green trees and grass, Washington Square Park is a favorite respite for those who work near Kansas City's Union Station and Crown Center complexes.

The park was dedicated in 1925. It boasts some of the most colorful bears in the March of the Teddy Bears.

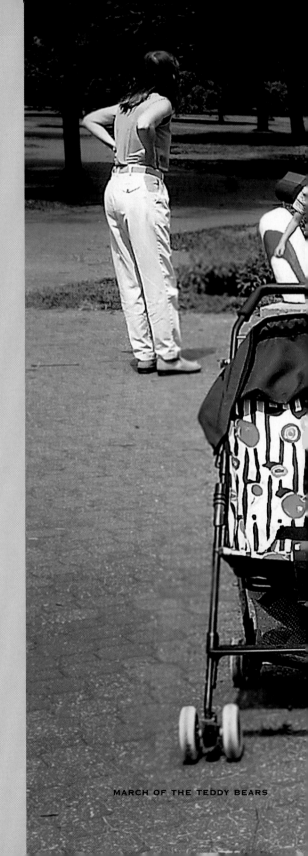

MARCH OF THE TEDDY BEARS

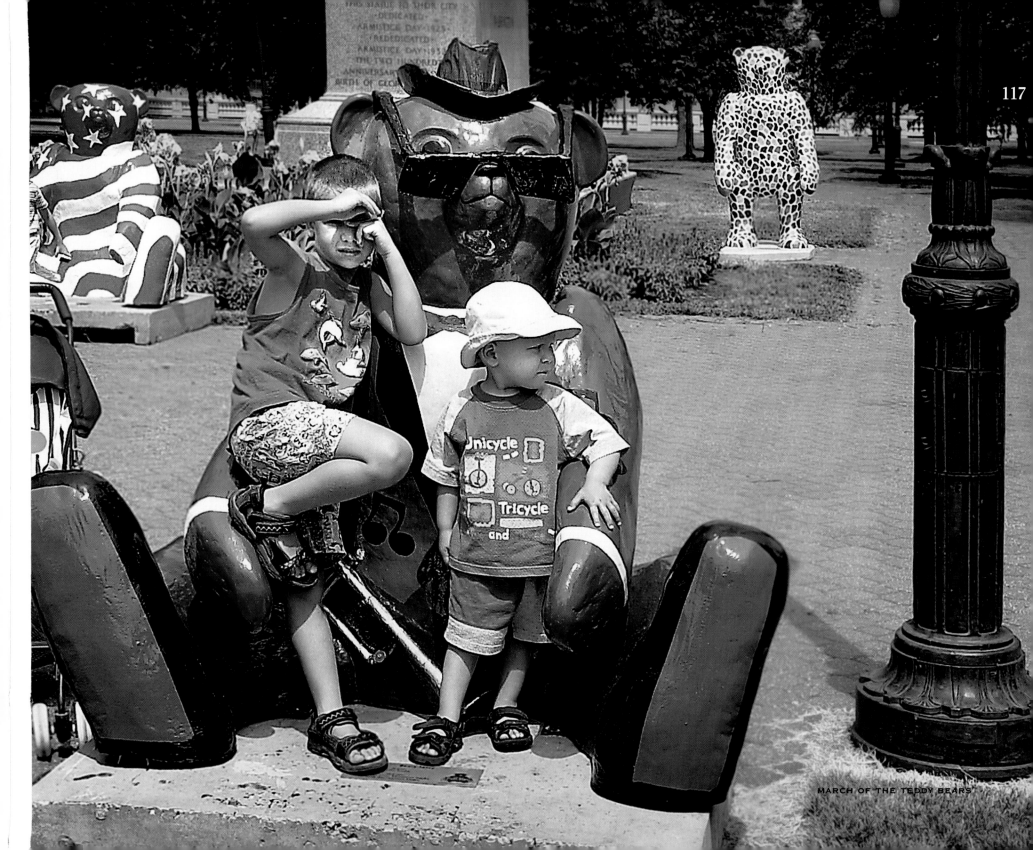

MARCH OF THE TEDDY BEARS

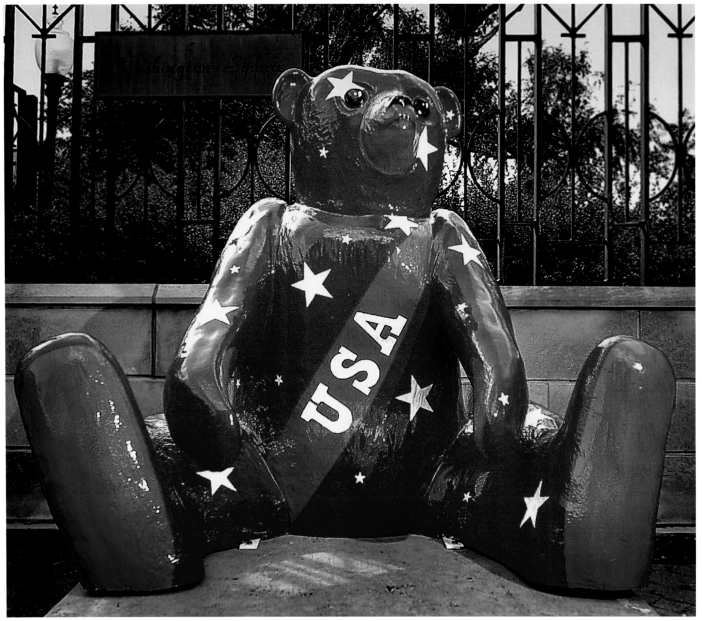

Star Spangled Bear
Artist: Carolyn Huntington
Patron: Digital Impressions

Starry Night
Artist: Edward Bartoszek
Patron: Kansas City, Missouri Parks
and Recreation Department

Green Bearet
Artist: Kimberly Francis
Patron: Neighborhood Tourism Development Fund

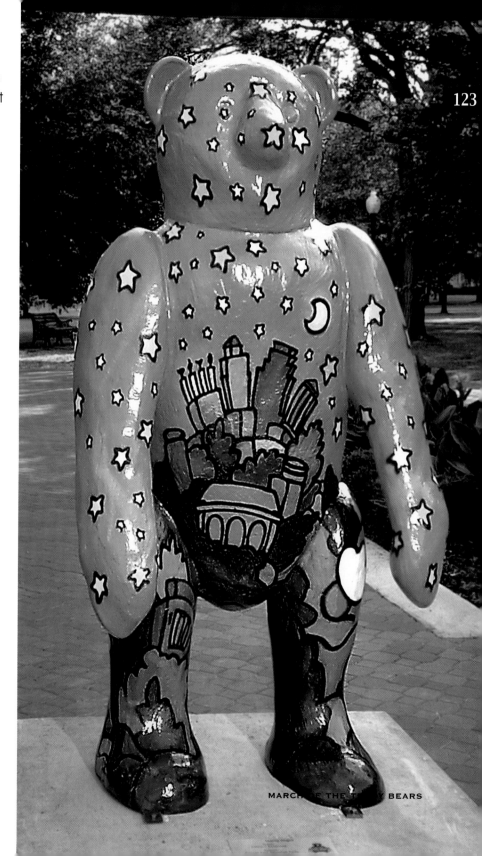

MARCH OF THE TEDDY BEARS

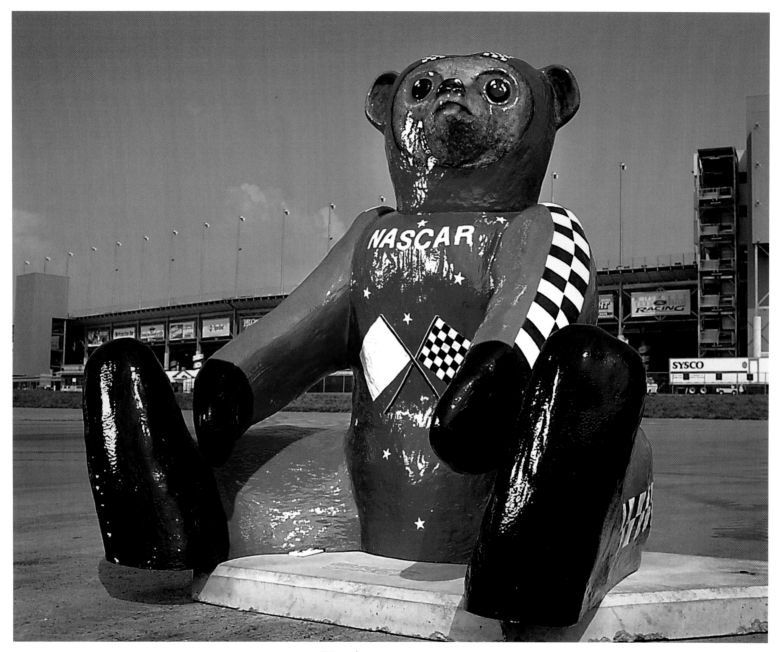

Nasbear
Artist: Carolyn Huntington
Patron: The Kansas City Star

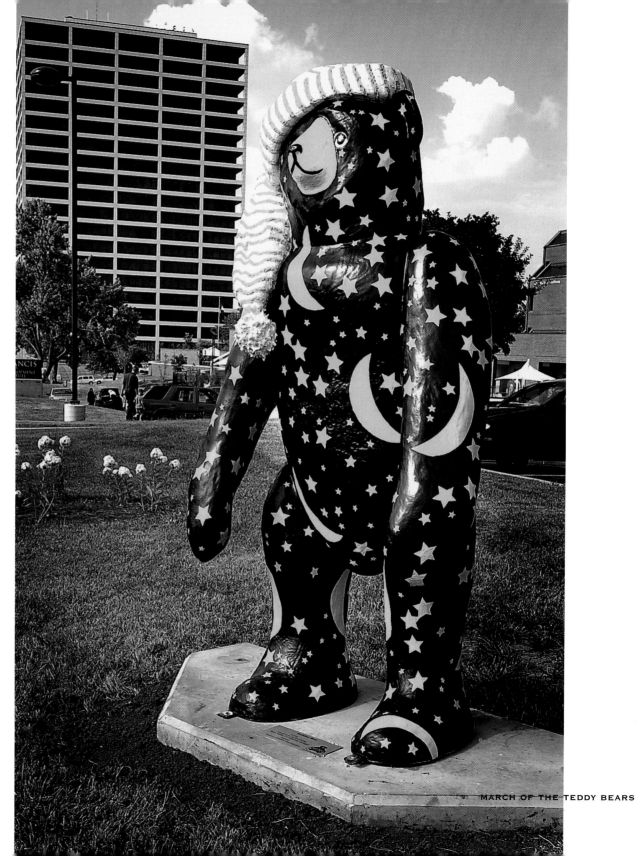

PENN VALLEY COMMUNITY COLLEGE

Bedtime Bear
Artist: Visual Arts Department,
 Penn Valley Community College
Sponsor: Francis Families Foundation

MARCH OF THE TEDDY BEARS

A BEAR GALLERY

 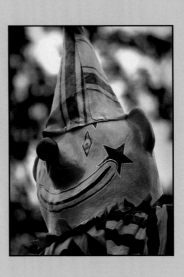

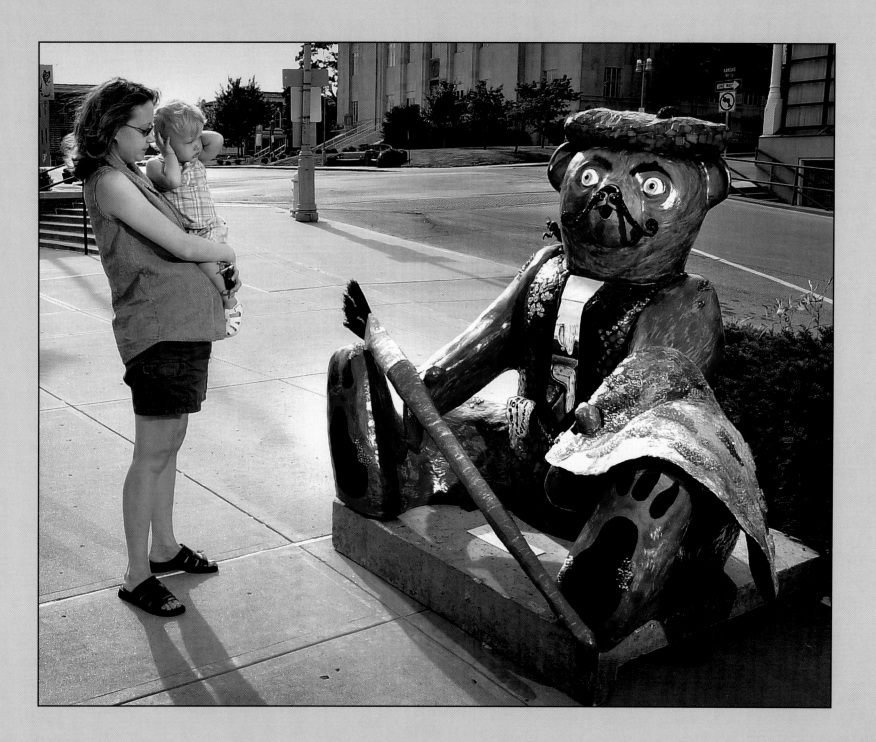

MARCH OF THE TEDDY BEARS

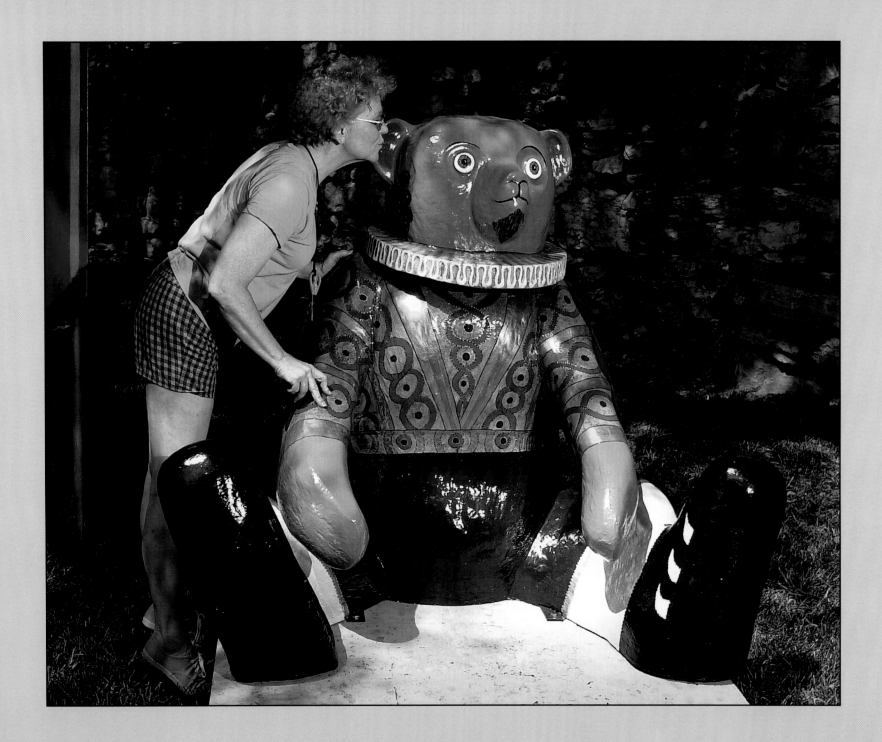

MARCH OF THE TEDDY BEARS

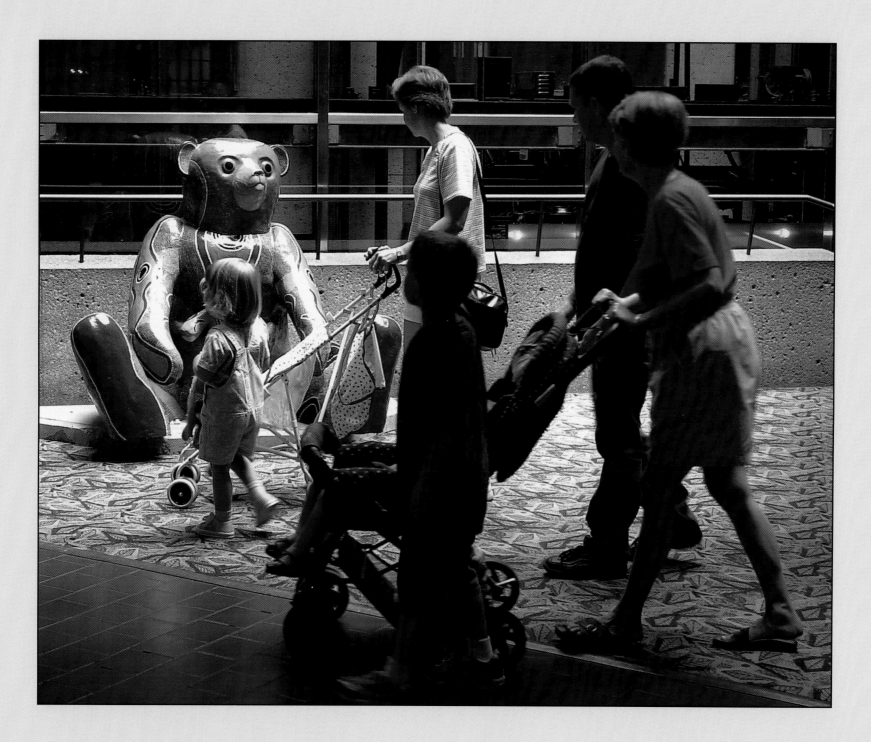

MARCH OF THE TEDDY BEARS

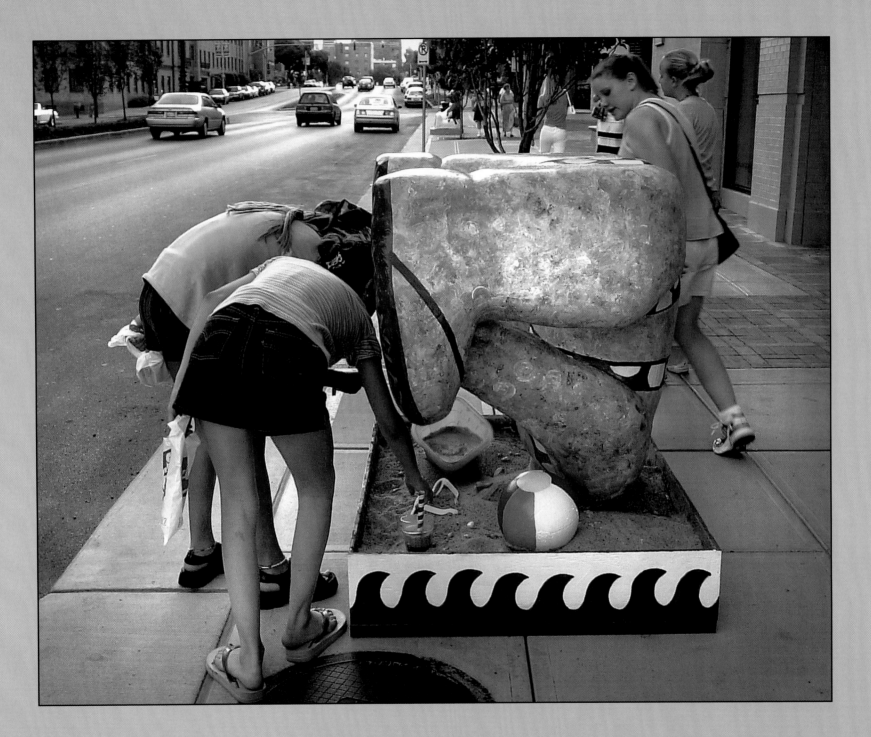

MARCH OF THE TEDDY BEARS

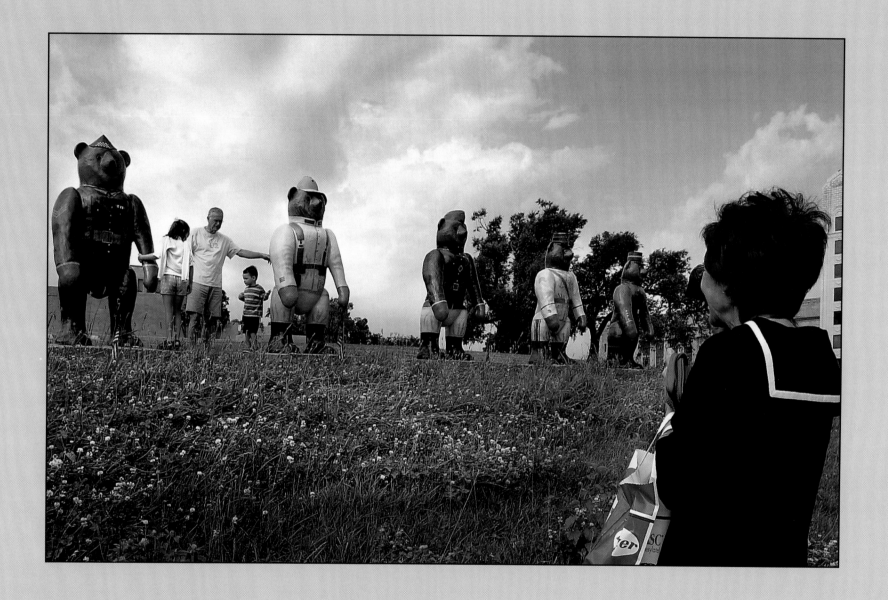

MARCH OF THE TEDDY BEARS

BEAR INDEX, ARTISTS

BEAR INDEX WITH SPONSORS

Bear	Sponsor
140 Years Young	FAO Schwarz
A Story Comes to Life	Crown Center
All A'bear'ican	The Kansas City Star
AuRoara Bearealis	James B. Nutter & Company
Ball Bear	Kansas City, Missouri Parks & Recreation Dept.
Bear Bank	Summit Woods Crossing
Bear B-Q	Highwoods Properties
Bear Dazzling	American Century
Bear Feet	Thomas M. Johnson, M.D. Charitable Fund
Bear Foon	Executive Marketing Promotions, Inc.
Bear Foot In The Park	Kansas City, Missouri Parks & Recreation Dept.
Bear Market	Crown Center
Bear the Builder	Friends of Children's Mercy Hospitals & Clinics
Bear To Not Be Surprised	Adelaide C. Ward
Bear-a-tone	City of Kansas City, Missouri
Bearfoot Teddy	Crown Center
Bearied Treasure	Executive Marketing Promotions, Inc.
Bearister	Polsinelli, Shalton & Welte, P.C.
Bearly Balanced Bearnini's	Francis Families Foundation
Bearly Hidden	Crown Center
Bears Repeating	Grand Street Cafe
Beary Beary Colorful	Executive Marketing Promotions, Inc.
Beary Fishy	The Kansas City Star
Beary Good Day to be a Kid	James B. Nutter & Company
Beary Jazzy	Kansas City, Missouri Parks & Recreation Dept.
Beary Patch	The Kansas City Star
Beary Princess	Friends of Children's Mercy Hospitals & Clinics
Beary Tourist	Convention & Visitors Bureau of Greater KC
Beary Truman	Taylor Cable Products, Inc.
Bearying Your Head In The Sand	Highwoods Properties
Bearymore of Broadway	Chuck & Joan Battey
Bedtime Bear	Francis Families Foundation
Belgium Bear	March of the Teddy Bears
Bluebearry Tea Party	Friends of The Toy & Miniature Museum of KC
Bluebeary	Blue Cross & Blue Shield of KC
Bozo Bear	Francis Families Foundation
Bubblegum Bear	Executive Marketing Promotions, Inc.
Buckle-Up Bear	Yellow Corporation
Carmen Bearanda	Crown Center
Centura Bear	American Century Foundation
Chiefs 40th Anni-BEAR-sary in Kansas City	Kansas City Chiefs
Chocolate Covered Polar Bear	Adelaide C. Ward
Classical Cookie Jar	The Kansas City Star
Construction Bearrel	Francis Families Foundation
Cub Reporter	The Kansas City Star
Dr. K.C. Bear	Thomas M. Johnson, M.D. Charitable Fund
Elvis Bearsley	James B. Nutter & Company
Flight of the Red Bear-on	Highwoods Properties
France Bear	March of the Teddy Bears
From Bear Ground Spring Flowers	Bill & Carlene Hall
Garden Variety Bear	James B. Nutter & Company
George Bear-ett	MAI Sports
Green Bear	Kansas City, Missouri Parks and Recreation Dept.
Green Bearet	Neighborhood Tourism Development Fund
Grin and Build It	JE Dunn Construction
Happy Bearthday	Don & Adele Hall
Hi Bear Nate	James B. Nutter & Company
Hide-N-Seek Bear	The Learning Tree
Honey Bee Bear	Francis Families Foundation
Huckle Bear	Executive Marketing Promotions, Inc.
Huggable	Friends of Children's Mercy Hospitals & Clinics
Huggable Hero	Build-A-Bear Workshop
I Am Loved	Helzberg Diamonds
Italy Bear	March of the Teddy Bears
Jerry Bear, The Grateful Bear	Crown Center
Jungle Bear	Friends of Children's Mercy Hospitals & Clinics

K.C. Jones	Kansas City, Missouri Parks & Recreation Dept.
Kanga Bear	Crown Center
King Tut Bear	Friends of The Toy & Miniature Museum of KC
Les Miserables	Starlight Theatre
Let's Go To The Movies	Dickinson Theatres
Libeary	Friends of The Toy & Miniature Museum of KC
Mad Hatter Bear	Grand Street Cafe
Marbleous Minnie's Many Marble	Francis Families Foundation
Marching Teddies	Video Post Production
Memorial Liberty Bear	Ash Grove Cement Co.
Mercy Bear	Friends of Children's Mercy Hospitals & Clinics
Mr. Brrr Bear	The Kansas City Star
Mrs. Brrr Bear	The Kansas City Star
Nasbear	The Kansas City Star
Neuro Bear	Teva Neuroscience
Paper Bear	Friends of The Toy & Miniature Museum of KC
Peter Panda	Crown Center
Rocketman	Highwoods Properties
Safety & Security	Schlage Lock Co.
SalvaBear Dali	Cates Auction & Realty Company, L.L.C.
Scarlet O'Beara	James B. Nutter & Company
Some Like It Hot	Bayer Corporation
Some Like It Hot in Kansas	The Kansas City Star
Star Spangled Bear	Digital Impressions
Starry Night	Kansas City, Missouri Parks & Recreation Dept.
Statue of Li-bear-ty	James B. Nutter & Company
Su Bear Man	The Kansas City Star
Tabatha, the Boo-Boo Bear	Friends of Children's Mercy Hospitals & Clinics
Tabearsco	The Kansas City Star
Technicolor Dream Bear	Starlight Theatre
Teddy Beer	Grand Street Cafe
Teddy Gonzalez	Aventis Pharmaceuticals
Teddy Rose-in-Bloom	Crown Center
The Cabinet is Bear	Executive Marketing Promotions, Inc.

The Honey Judge	The Kansas City Star
The Illustrated Bear	Cates Auction & Realty Company, L.L.C.
A Beary Good Question	James B. Nutter & Company
Theo-Bear Roosevelt	Friends of The Toy & Miniature Museum of KC
Tiger Bear	Friends of The Toy & Miniature Museum of KC
Tin Bear	Keith & Margi Pence
Too Tall Pawl	Francis Families Foundation
Trained Bear	Friends of The Toy & Miniature Museum of KC
Under Bear	Hunt Midwest
United Kingdom Bear	March of the Teddy Bears
United States Bear	March of the Teddy Bears
Ursa Major	Crown Center
William Shakesbear	Town Center Plaza
Willie Shakesbear	American Century
Wind-Up Tin Toy Teddy	Crown Center
Wish Upon the Stars	Steadman Family Foundation

Sponsors that had not selected bear characters by presstime:

Sponsor	Bear location
KMBC-TV 9	Starlight Theatre
Neighborhood Tourism Development Fund	Ilus Davis Park
Neighborhood Tourism Development Fund	Line Creek Park
Neighborhood Tourism Development Fund	Mill Creek Park
Neighborhood Tourism Development Fund	Washington Square Park
UMB Financial Corporation	Ilus Davis Park
UMB Financial Corporation	Liberty, MO
UMB Financial Corporation	Washington Square Park

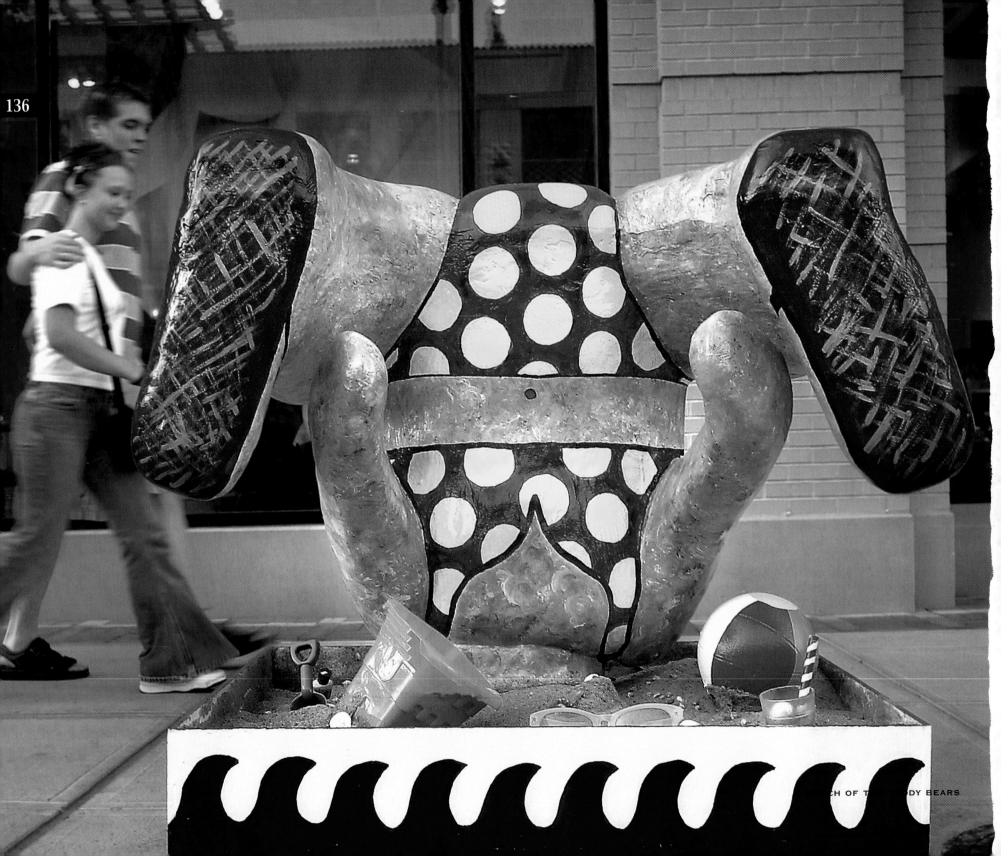